How to Start a Pet Photography Business

By Kyle Richards

Copyright © Kyle Richards 2014 All Rights Reserved. No part of this book may be reproduced without our express consent.

Table of Contents

Introduction	1
Pet Photography	3
How Challenging It Could Be	7
Essential Qualities	11
Posing	15
Lighting	19
Developing The Business Plan	21
Mission statement	25
Principals	27
Legal Structure and Organization	28
Product Line	31
Financial Plan	36
Operations Plan	45
Equipment and Inventory	51

Starting The Business	52
Marketing The Business	79
Public Relations	112
Running The Business	121
Taxes	156
Pet Photography Basics	160
Pet Grooming	171
Safety and Welfare	175
On Arrival	181
Choice of Environment	185
Pet Portrait Tips	195

Introduction

Do you love to take photos? Do you love animals? Then starting your own pet photography business might be a good path to take. Here you will find practical steps from the creative end, to the business end of starting your own pet photography business.

Learn your camera well, master shooting on manual mode. If all you have is a simple point and shoot camera, and only use it on auto-mode, you are not ready. You may want to take some classes or some other type of educational resources to develop your base photography skills.

All the photos in this ebook were taken by me. My clients and I both prefer to photograph their pets in their own home settings and outdoors. It's just our

preference. Some pet photographers prefer a studio setting (or both), and that's the beauty of having your own business, you can customize it to you and your clients' desires.

Towards the end of the book we'll have practical tips on the actual photography side. Keep reading.

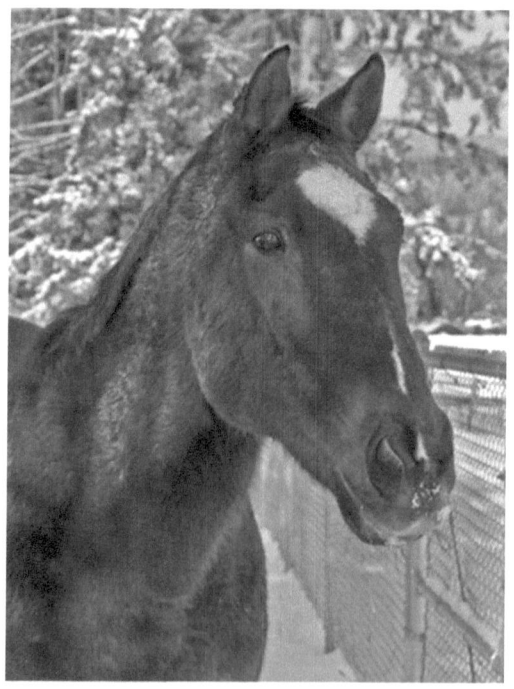

This taken at F-stop 9, 200 ISO, 1/200th sec.

Pet Photography

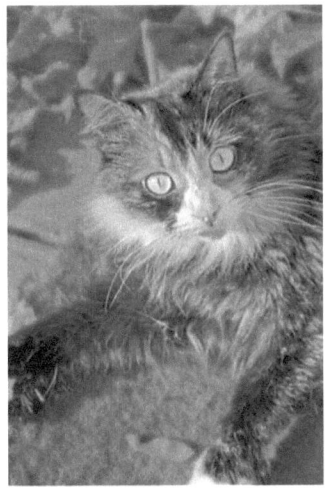

This taken at F-stop 5.6, 160 ISO, 1/400th sec.

Don't think that a captivating a great animal picture is merely the result of a lucky accident! It takes patience, ingenuity, much planning, and mastery of a few rules to take good animal pictures. The satisfaction and results you obtain more than compensate.

Some tricks could be employed in a variety of situations. Suppose that your cat always stretches and puts on a bored expression when disturbed in his favorite sleeping corner. If your camera is all set up ahead of time and you are quick on the trigger, you will get that picture. However, don't expect to get your best results with one try. Take a number of shots, and you will capture that fleeting expression you are after.

The animal need not be your own. Pet owners are usually more than cooperative, and you will be better able to handle your equipment if the owner lends a hand in posing. Have the pet owner introduce you to the pet and allow plenty of time and space for it to feel comfortable. Approach slowly with no sudden motions, and allow it to sniff at the camera so it will not be suspicious of the equipment.

How to Start a Pet Photography Business

Don't assume pet photography is just about cats, dogs or horses. While it does include those, be open to the possibility of it being very different types of animals.

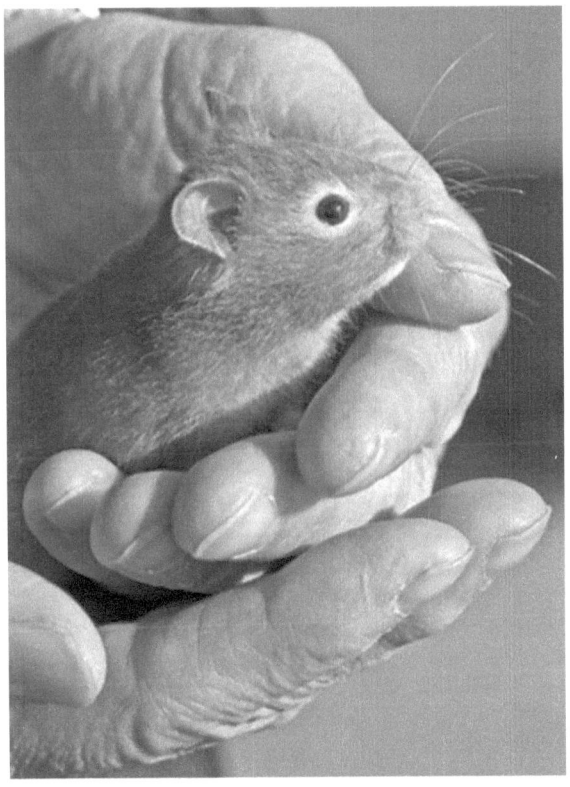

This taken at F-stop 10, 200 ISO, 1/400th sec.

This baby gray hamster being held in the loving owner's hands, brought warmth to this client's heart seeing this photo.

How Challenging It Could Be

If there is one area where props are more valuable than in photographing small children, it is in photographing pets. Four-legged creatures seems to move approximately four times as fast as two-legged subjects and can be sixteen times as exasperating. There is no easy formula, but it is an interesting game, and patience plus watchfulness can eventually equal success.

Of course, the use of props really is up to the client and the look they are after. Dogs can be especially cute dressed up in hats, glasses or other costumes. Props may also be as simple as their favorite toy, giving the owner a capture of a very ordinary life moment they are familiar with.

Kyle Richards

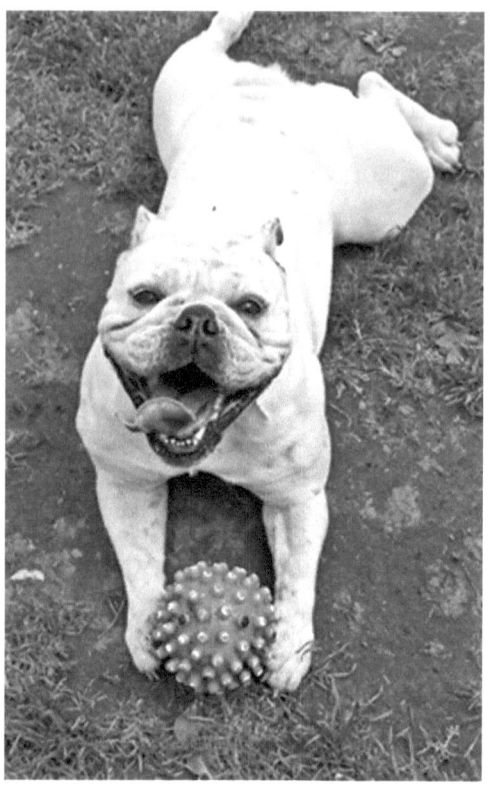

This taken at F-stop 9, 200 ISO, 1/320th sec.

Pets and children seem to possess an infallible affinity for each other, and first encounters may offer choice photo opportunities. A puppy or kitten is normally gentle with youngsters, but children need to be taught to be gentle. Picture possibilities are limitless.

Animals offer endless variations in personality and behavior; however, they are generally less manageable than children, less dependent on adults, and less susceptible to obvious coaxing. Try to set an environment that is friendly and familiar to the pet and watch to get that sweet candid moment.

Another point: because pets move faster than people, the photographer should approach their subject slowly – not stealthily, but naturally – and refrain from sudden movements that might startle the animal. If your camera is on a tripod or otherwise vulnerable, watch out for sudden movements by the pet. And beware the dog whose friendly tongue may lick your lens as well as your hand.

Essential Qualities

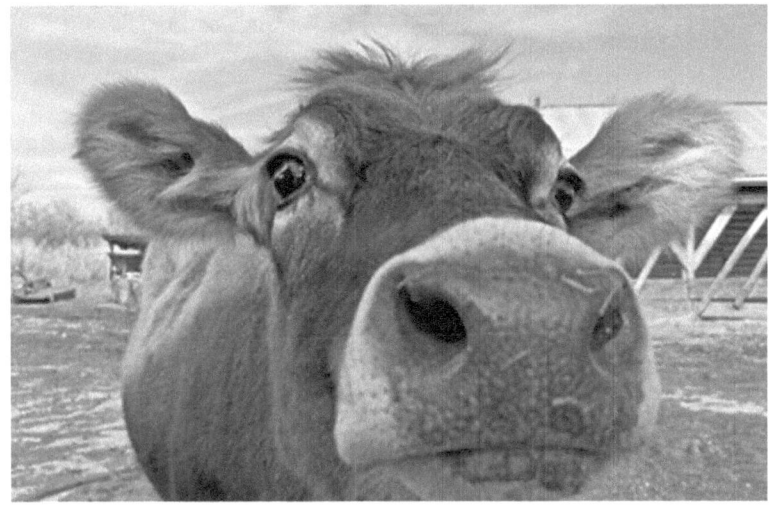

This taken at F-stop 8, 160 ISO, 1/400th sec.

You have probably seen many animal pictures that you took a liking to instantly. What do these outstanding pictures have in common? The first thing is "human" appeal. This is expressed by attitude-alertness, cuteness, and other facial expressions. The appeal is usually greater if the animal is doing something, not just posing.

Next comes the print quality. This includes the composition as well as brilliance and snap.

Sharpness is a must, especially for furry animals. Then, too, there should never be large areas so dark or so light that detail is lost. Nor should the subject range merge with the background because of similarity of tone. For example, most black and white films would register a brown horse against green foliage with the same tone. A lower camera angle with sky for a background would give better separation.

Action

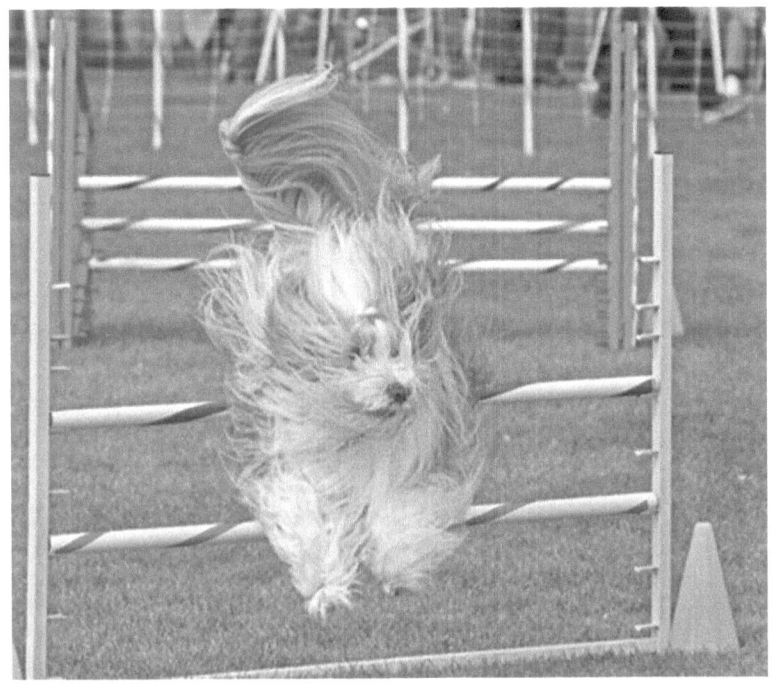

This taken at F-stop 4.5, 400 ISO, 1/1478th sec.

In capturing fast motion, there are several simple facts to keep in mind. Fast shutter speed is not always the answer, but in many cases it is. The image may call for such a large f-stop that depth of field will be too shallow for a successful picture. Most fast actions have a peak. For example, a deer leaps into the air; it appears to hover for a moment before descending. That is the

instant to release the shutter. Even 1/50-sec shutter speed might be sufficient. Too short an exposure may "freeze" the action to a point where it appears static, and sometimes this is the effect you are after. If a paw or tail is slightly blurred, it sometimes gives the impression of action better than if the picture is tack sharp all over.

Another trick is panning, which involves moving the camera with the animal. This gives an impression of speed because the background will be blurred although the animal is sharp.

A blur may be at its worst when the subject is too close to the camera and when the motion is perpendicular to the direction of the camera, or the animal is moving in low light.

Posing

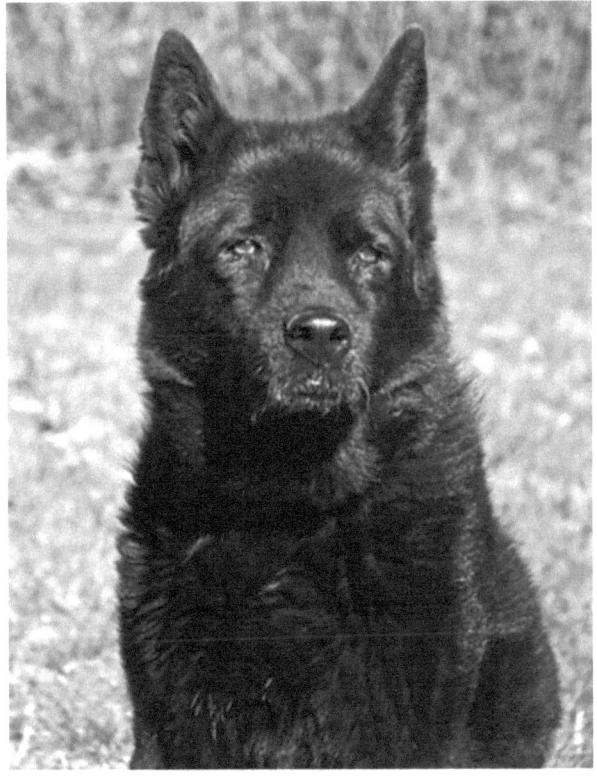

This taken at F-stop 6.3, 160 ISO, 1/200th sec.

Owners of championship dogs naturally want them portrayed to their best advantage. It helps to have them bathed and brushed. Even a well-trained dog at times cannot be expected to pose long enough for a picture

with no leash or without the owner's hand in view. This difficulty is easily overcome with a little ingenuity and lots of patience.

As photographic subjects, cats are quite different than dogs. It is very hard to induce a cat to do something it does not want to do. When working with them, infinite patience and ingenuity are more important than expensive photographic equipment. When posing them in a restricted area, choose a place quite high or you may find yourself suddenly minus a model. Even a small kitten does not mind a three foot jump. Bright bits of colored cloth, string or feathers on the end of a stick are good attention getters. Your model is more likely to stay put on a cushion or other soft surface than on one that is smooth and hard.

The camera should be on the tripod (if you are using one), lights should be in place, your camera settings dialed in for the circumstances, and everything should be ready before putting your subject in position. An assistant would be most helpful. You want to be able to focus on pressing the shutter button at precisely the right moments.

You may also want to set situations up with a pet, to get interesting candid shots. Such as a kitten with a tiny bowl of milk, a dog with a spoonful of peanut butter, a bird and its bird bath, or simply a brand new appropriate toy or favorite food.

Lighting

We're going to keep this section short and sweet as it can be so extensive that whole books are written on the subject. You may need to study this topic in depth further, unless you are already adept at it. Personally I have found using a light meter a very valuable tool of the trade.

If you use a photo studio, the rules for portrait lighting apply to this type of photography with only one exception: better definition will be obtained when the main light is at a 45 degree angle and the fill light is a reflector bouncing light into the darker areas. One caution however, many times the use of flash can be very difficult on animals, and continuous lighting might be a better option, with light reflectors acting as your fill lights.

Even with natural sunlight, a reflector or lower powered flash helps to fill in the shadows. Sunlight can cast very harsh shadows, and by using some type of fill light, helps to soften the shadows and ensure that those areas are properly lit. Overcast days can make great lighting conditions. Get your lighting and camera settings correct before you put the subject into the scene.

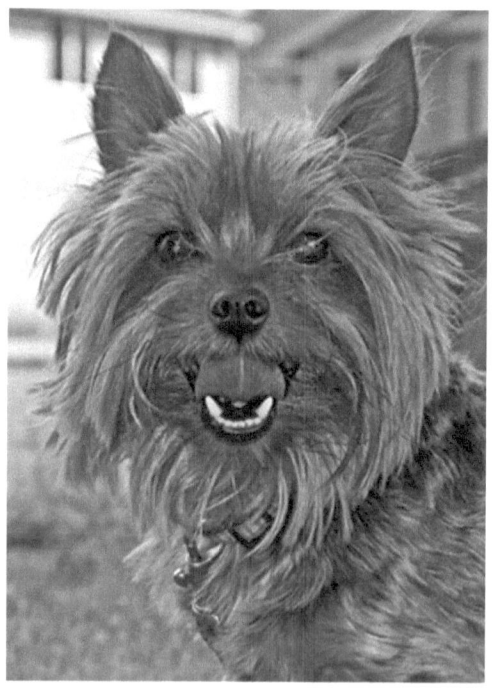

This taken at F-stop 9, 200 ISO, 1/200th sec. fill flash used

Developing The Business Plan

You are now ready for one of the most important steps in establishing a business: the preparation of the business plan. Let me guide you with the following:

1. Learn the basic purpose of the business plan.

2. Become familiar with all the elements of the business plan.

3. Establish your business goals.

4. Value your goals in financial terms.

5. Value the costs of attaining your goals in financial terms.

6. Develop detailed financial, marketing, and administrative plans to attain your goals.

Kyle Richards

The Importance of Assumptions

For any business plan to be of use to you, the assumptions it makes have to be credible. The old saying about computers that if you put garbage in you'll get garbage out is true for business plans. It is difficult to provide specific guidance on making assumptions because each business situation is unique. It is, however, possible to provide guidelines and guidance on technique. As you rely on the material to develop your own business plan, put great effort into making your own assumptions, subject them to intense scrutiny from your peers as well as yourself, and don't hesitate to derive a variety of scenarios based on changed assumptions before you settle on what you think is the most likely option.

Elements of the Business Plan

The elements of the typical business plan are quite straightforward:

1. Mission statement

2. Principals

3. Legal structure and organization

4. Product line

5. Financial plan

6. Marketing plan

7. Operations plan

Let us see what they are all about.

Mission statement

Every business plan should start with a mission statement. The mission statement should be very brief and to the point, preferably one or two sentences, precisely summarizing the key objective of the business you plan to start. The purpose of the mission statement is to crystallize your thoughts to help you focus explicitly on what you are proposing to do. It is always there to refer to and keep you on track as you go through the process of planning and even running your business. Here is a typical mission statement for a photography business:

E.g. Provide quality pet photography to the high-class residential community in the greater (your area) at competitive market prices.

A great deal of background work and thought has gone into this statement. It reveals very precisely defined parameters and objectives to keep the photographer focused on a profitably manageable task. Let's see what went into deriving it.

Based on their training, talents, and interests, the photographer sees a career for themselves in pet photography. To make this statement, the photographer must have good reason to believe that they are capable of providing "quality pet photography" and likes the fact that pet photography is one of the latest trends in the photography market.

Principals

The next step is to identify the principal or principals who will own and operate the business, including a detailed presentation of their qualifications. A principal is defined as a person who has an ownership interest in the business. In most cases, this will be the photographer alone, or it could be several photographers in partnership, or it could be a partnership between the photographer and his or her spouse in the role of office or marketing manager.

There are two reasons to provide a detailed qualifications summary, even if the photographer is the only principal:

1. It helps the photographer confirm to himself/herself that he/she has the requisite skills.

2. Banks and other institutions who will eventually be asked to extend the business credit will want to know.

Legal Structure and Organization

For the purpose of business planning as well as for the information of any outside readers of the plan, the legal structure and organization of the business has to be established. Choices could be:

1. Sole proprietorship
2. Partnership
3. Corporation
4. Subchapter S corporation

The mix of considerations that should go into making this decision include:

1. The photographer's (principal's) financial vulnerability in case of liability
2. The financial cost of establishing and operating the various forms of legal structure
3. The recordkeeping burdens of the various forms of legal structure
4. The personal and corporate income tax rate in effect

To review, in sole proprietorships and partnerships, the principals are personally liable to the full extent of their present and future financial worth. If the principals have significant personal assets, these can be lost in lawsuit, in addition to the loss of the business assets and the proceeds of liability insurance. Corporations, on the other hand, are liable only to the extent of corporate assets; the principal's personal assets are protected.

The drawback to corporations is that they require more record keeping and corporate tax filings, corporate officers, a board of directors and annual meetings, and there are various fees that have to be paid to start and maintain them. However, for people with significant personal assets, that is a small price to pay.

The subchapter S option is an attractive alternative if the personal income tax rate is lower than the corporate income tax rate because it allows business income to be taxed at the personal rate while providing all the legal liability protection of regular corporations.

Review your personal circumstances, and justify in the business plan your choice of legal structure. It would be wise to seek legal counsel as well to go over your personal circumstances.

Product Line

To be successful, every business has to have a well-defined, distinct product line formulated in the context of market demand and the competition. The product line has to be at least on a par with the competition; ideally, it should have certain features that distinguish it and elevate it above the competition. The business plan is the place to define in detail each product being offered and evaluate its strengths and weaknesses as compared to the competition.

One important reason for defining each product separately is to enable you to clearly understand the cost and income structure of your business and to calculate the profitability of each product. In this way, you will be able to rationally and efficiently assess where to put the most effort for the greatest return. It will also help you

determine what secondary products to fall back on first if demand for your primary product slackens temporarily.

To develop your proposed product line, first make a list of the typical assignments you would like to get. From this list, a pattern of different products will emerge. Isolate each product and write a concise definition of each one. When you are satisfied that you have developed a list of distinct products, develop a product sheet for each one along the following lines:

1. Description. Write a concise product description - will you be offering physical photographs, if so what sizes? Will you be offering CD's of their pictures?

2. Market. Identify the specific markets for the product. Describe the market (potential size, location, number of buyers, etc.) and state why there is room

for your product. List the types of communities your product is targeted to; assemble a specific list of community representative of your target market. List the positions of the key buyers within the types of community you are targeting.

3. Pricing. Develop the pricing of the product per some appropriate unit of measure. In most markets except retail, your pricing will be on a fee plus costs basis. While you should probably add a 10 to 15 percent markup to costs before passing them on, the bulk of your income will be in your daily fee. Estimate all the time required to complete a typical job, including the time spent preparing and presenting the proposal, making the sale, processing and delivery; all the time for which you are not receiving your daily fee. Take the income generated by the job and divide it into the typical total time (in hours) spent on the

job to arrive at a measure of hourly profitability. This figure will give you a good idea of how lucrative the product is.

4. Competition. Identify and describe the competition you have for the product. Identify the similarities and differences between your product and the competition's.

5. Strengths. Describe the strengths of your product in relation to the competition's.

6. Weaknesses. Describe the weaknesses of your product in relation to the competition's.

When you are finished with the individual product descriptions, rank them in terms of profitability and your

preferences to determine what you consider to be the ideal, prioritized product line.

Do you plan to be a generalist, photographing every type of pet? Or do you plan to specialize? If you choose to specialize, how far do you want to go in the speciality? An example is if you want to photograph only horses, will you want to specialize even further to only Arabian horses?

Developing your product descriptions and product mix requires a lot of research, analysis, and hard work. Expect to make many passes through the product line evaluating, modifying, adding, and discarding products until you come up with a competitive mix.

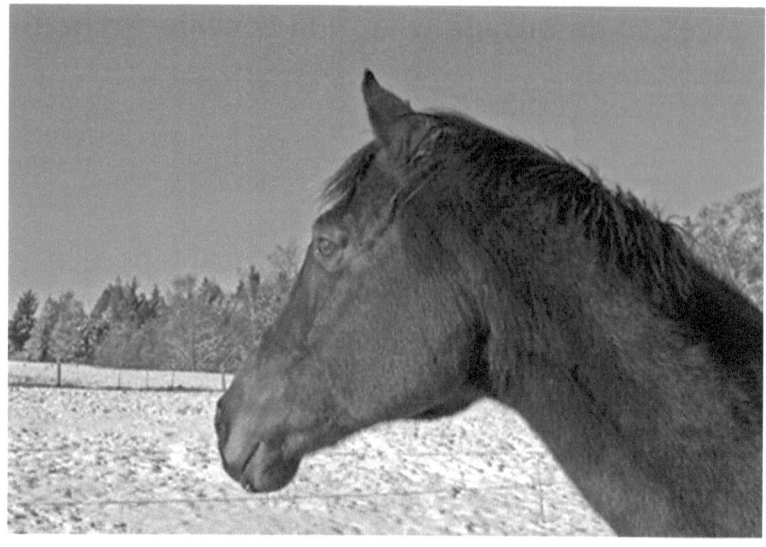

This taken at F-stop 10, 200 ISO, 1/200th sec.

Financial Plan

This can be considered the heart of the business plan. If it is accurate, the photographer will prosper. If it is flawed, income will suffer, and the business might even fail. The product line, marketing strategy, and administrative practices are fairly easy to revise midstream if necessary, but a serious flaw in the financial plan is difficult to correct, especially if capital

has been depleted without generating the forecasted commensurate income. For the financial plan to be accurate, the assumptions have to be realistic, and there has to be some room to maneuver; the more the better. The financial plan has to address five major points:

1. Sources of start-up capital
2. Start-up costs
3. Projected income and expenses for the first three years (income statement)
4. Projected monthly cash budget for the first year

Start by putting down on paper the amount of capital you have available for your venture. As you get further into the financial plan, you will get a sense for how long it will take to generate enough income to start exceeding expenses. But right from the start,

you should assume that the income stream will not meet your monthly expenses for at least six months, and you should plan on having the resources to make up the difference. Businesses often take much longer to start generating income than would seem reasonable, so a conservative assumption in this regard is strongly advised.

Let's say you have $25,000 in savings. You own a car worth $10,000 and have $5,000 in camera equipment (assume you have already acquired the camera equipment prior to deciding to go into fulltime photography). How much capital do you have? You have $25,000 + $10,000 + $5,000, which is equal to $40,000. Some of it is already spoken for (the car and equipment that you already own), but the entire amount is important to list, because all of it represents capital (equity) going into the business.

At this stage, a word about additional sources of funds that you might be tempted to consider is needed. How about borrowing? No bank is likely to lend you any money unsecured, because your prospects are highly unpredictable and pose an unacceptable level of risk. How about getting a home equity loan if you own your home? You would be taking a tremendous risk, because if the venture fails and you can't make the payments on your loan, you will be jeopardizing your home.

If borrowing is not an option, then how about relying on the salary of a spouse to fund initial losses? First of all, that is not capital because it is received monthly. Secondly, you will be deceiving yourself if you incorporate such income as a source of funds, because it is mixing a nonbusiness source with business sources, and you will not know accurately

how your business is doing. It is perfectly legitimate to rely on such income (if your spouse is willing, of course) to get your business going, but track it as a source of funds under the bottom line, as an extraordinary source above and beyond the business, available to make up any shortfalls.

What about a home equity loan to provide start-up funding if you have a reliable outside income source to make the payments (such as a spouse's salary)? That might be a reasonable plan, but use it only if you really need it. If not, then keep the idea in mind as a contingency, a fallback to rely on only if your plans are not working out as quickly as you had estimated.

Perhaps you have savings that you could use. You could also check out your local small business association to see about possible grants or loans

there. Perhaps you could find another investor into your business.

The next step is to outline all the start-up expenses you anticipate. Read through the rest of the financial plan section now, but before you estimate your start-up expenses, finish the ebook to become aware of all potential expenses and how to estimate them. Estimated start-up expenses (uses) are listed in the sources and uses table along with available start-up funds (sources):

Sources and uses of start-up funds

Sources	$
Savings	25,000
Equity already owned (cameras and car)	15,000
Total sources	40,000
Uses	

Camera equipment (already acquired)	5,000
Car (value of car already owned)	10,000
Computer equipment and software	3,000
Communications equipment and lines	500
Stationery, business cards	300
Promotional materials	2,000
Legal and accounting advice	500
Company formation fees	200
Total start-up expenses	21,500
Working Capital	18,500

The funds available for working capital is the money you have left over after start-up expenses to pay your ongoing business expenses until the business starts to generate monthly income in excess of monthly expenses. If spent over a six-month period, the $18,500 of working capital could pay monthly

expenses of $3,083. Thus, if you are giving yourself a six-month window, your business could generate monthly expenses of $3,083 and no income to survive that long. From the sixth month on, though, it would have to bring in at least $3,083 to keep going.

The assessment of sources and uses of start-up funds is a good beginning. You know how much money you have to start, you have an idea of what start-up expenses might be, and you know how much money is available monthly for a six-month period without the generation of income. The next step is to make as realistic an estimate as you can of the annual income and expenses you expect to realize in the first year of operations. When this analysis is done, prepare a monthly cash budget for the first year to see if you will be able to generate enough income to meet monthly expenses before you run out of initial

working capital. Work through the marketing and operations sections of the business plan first; you need these results to accurately estimate potential income and expenses.

Operations Plan

The last major component of the business plan is the operations plan. Its purpose is twofold: to set out a schedule of key events that will get the business established, and to establish a set of key operation procedures to run the business.

Schedule

Lay out in the schedule all the events that have to take place and tasks that have to be done to get the business established. A typical schedule might look something like this:

January 15 Acquire computer
Have telephone and fax lines available

Join all appropriate professional and civic organizations

Commence business plan

Start developing promotional material and stationery

February 25 Complete market research and product development sections of business plan

Finalize arrangement for business premises

Choose company name

Complete company formation (verify trade name availability, do all filings, pay fees, get tax ID number, etc.)

Transfer telephone and fax numbers to company name, or add company lines

Open and fund business bank account

Set up and start using company accounting system

Get business cards, stationery

March 15 Complete financial plan section

Complete promotional material design and production

Line up direct mailing list, complete setup marketing database

Place advertising

March 31 Complete entire business plan

Complete any last-minute photographic equipment acquisition requirements

Establish initial calling schedule

Complete the development and production of all standard contracts, model releases, and other forms

Send invitations for opening reception

April 15 Hold official opening reception

Complete initial assignments lined up from clients known from prior experience

Complete initial direct mailing

Commence regular marketing calls

This section of the operating plan should address the day-to-day operations of your business from the financial, marketing, legal, insurance, and tax perspectives – in other words, all those aspects of everyday business management that are essential but not necessarily fun.

The operations section should outline in detail the kind of financial and marketing recordkeeping systems you will have for the ongoing operation of your business, how they will be maintained (daily, weekly, monthly tasks), and what periodic summary financial and marketing reports you will use to track business performance. It should cover the legal contracts, model release forms, and any other legal forms you need and should contain samples of the

forms you plan to use. It should address all insurance needs and how they will be met. It should also cover your tax record keeping and report obligations, how they will be handled, who will prepare your annual income tax filings, and what arrangements, if any, if you will be using the services of accountants or bookkeepers.

Equipment and Inventory

In this part, list all the equipment, supplies, and materials you will need in your pet photography business. The reason for this is to have an idea of the associated expense and to avoid any nasty financial surprises when you realize you forgot something expensive. Typical items to be included are:

1. Photographic equipment (cameras, lighting equipment, lenses, post processing software, etc.)
2. Photographic supplies
3. Computer equipment (CPU, monitor, printer, notebook, computer, etc.)
4. Communications equipment (telephones, fax, etc.)
5. Opening inventory of business cards, stationery, forms, and promotional material

Kyle Richards

Starting The Business

This taken at F-stop 5.3, 1600 ISO, 1/60th sec. with flash fill

It is often said that to do something well, the greatest effort has to go into laying the groundwork. The culmination of the groundwork required to start and run a business is the business plan. It is the road map to guide you in getting underway, and if it is a detailed and accurate map, setting out on the trip will be a predictable and exciting affair. It will be backbreaking work, but you will always know exactly what to do next and will soon

settle into the routine of running the business day to day.

In this part, you will see how to put your business plan into action and how to cope with the demands of running a business. This area will cover how to make sure that all tasks (marketing, assignments, financial, and administrative) are done, how to identify critical, time-sensitive tasks, how to prioritize your activities, and how to motivate yourself to do the tasks not entirely to your liking. It will also address how to conduct yourself with clients, how to sell, and how to deliver.

Once the business plan is completed and a start-up schedule set, the main objective is to establish the business in the shortest time possible. The sooner you start doing business, the sooner you will generate income. Your business plan tells you the time frame you

have for use of your limited start-up resources, and when the clock starts ticking, you will experience firsthand that old business adage that time is money. The sequence for completing the various tasks is important in order to be as efficient as possible. Following is an outline of the tasks that need to be accomplished and the order in which it is advisable to do them. There is a certain amount of overlap in the timing of the various tasks, and depending on individual circumstances, some flexibility might have to be employed in following these recommendations.

Establish your Business Identity and Place of Business

For business as well as psychological reasons, it is important to formally establish your business identity and your physical place of business up front. Formally existing as a business and having a physical place of

business will give you a degree of credibility in your dealings with the business world. It puts everyone on notice that you exist as a business and function as one. You have to have a formal business identity in order to open a business bank account, establish phone and fax lines, and get your promotional material done. It is also an important boost to your morale. "I legally exist as a business. I have a place of business. Therefore, I must be in business," you'll say to yourself. Before you know, it you'll be acting as if you have been a businessperson for years. Even if you do this out of your home, dedicate specific space for business purposes only.

There are two stages to this first step. First, establish your legal business identity. This is very easy if you are going to be a sole proprietorship. In most places, you need only file a "doing business as" (d.b.a.) form at the town hall and pay a small fee. A partnership requires the

preparation of a partnership agreement, and if you choose to incorporate, there is the more complicated process of filing for incorporation. Whatever your choice of legal existence, check the specific requirements in your location by contacting the Secretary of State as well as your local town hall. Your accountant or lawyer will also be able to help. For the establishment of anything but the simplest sole proprietorship, you should get professional help. The point is to get it done.

Second, establish your place of business. When you prepared the business plan, you researched the cost and general location of your business. If you have chosen to work out of your home, then you need only to isolate your office area from your living area so that you have a space where you can work effectively. If it is impractical to work out of your home, you have to acquire the kind of commercial business space you scouted out while

preparing your business plan. It might take some time to find suitable space, so locate a commercial real estate agent with a long list of likely properties and start your search early. Besides providing a business address, an established business space allows you to start working in earnest.

Open a Checking Account for the Business

The minute you start functioning as a business, you will have payments to make, and you will have to keep the capital of the business somewhere. Also, you will have to start keeping track of the business's financial affairs from the first financial transaction. Before you existed as a business and had a place of business, you could not establish a business checking account, but now you can and should.

Choose a bank that is easily accessible, and compare business account terms at the various banks. All banks have a variety of business account packages designed for different levels of banking activity at different prices. Have an account officer take you through all the options, and, in general, choose the simplest, least expensive checking account to start with. You can always upgrade to different levels of service later if you need to. Deposit the capital going into the business as the opening deposit, and as soon as the account is established, use it to pay all the business expenses by check. The easily maintained business checkbook thus becomes the business's core financial record. This information is then entered into the accounting system.

If you have a large amount of capital going into the business that will be used over a long period of time, you should consider putting most of it into an investment

account that earns interest. Make periodic transfers into the checking account as required by cash needs. Ask the bank about such investment options.

Get Computer and Communications Equipment

You should already have gotten a computer before you prepared the business plan, but if you used someone else's, then now is the time to get one along with word processing, accounting, and database software. You need to start writing letters, keeping accounts, developing client databases, and more. You cannot afford to be without a computer.

You should also establish telephone and fax lines and get the associated equipment. Clients and business associates will get suspicious if you claim to be a business but don't have a phone number. There are

several options to consider when establishing communications lines. You can get two separate lines, one for the telephone and one for the fax. This is expensive and is not necessary if you don't expect heavy fax traffic. The best solution is to put the phone and fax on the same line to start. But how do you distinguish between the two lines? The answer is shared line service. This allows you to assign more than one telephone number to the same line. Pick one to be the fax number and one to be your business number.

Another service you should get is call waiting. This allows you to handle two calls at once instead of giving a busy signal to callers when you are on the line.

As far as the equipment is concerned, telephones are now fairly inexpensive, so whatever style suits you should be fine. There is no need to get the fanciest, most

expensive, plain paper fax machine. An inexpensive one will do an excellent job.

You will also need an answering machine to answer those important calls while you are away. Perhaps the most efficient solution is to get a fax machine with a built-in answering machine, because then you can use it on the shared line for your telephone as well as your fax.

Cell phones are a necessity as well. You might opt to get 1 landline for your fax machine, then use the cell phone completely for your business.

Get Business Cards and Stationery

You should get that all-important proof of your business existence, the business card, as soon as you know your business name, address, and phone/fax numbers. You

will also need to communicate in writing as soon as your business is formed, so you should get stationery at the same time. Most high-volume commercial printing/copying services can efficiently and economically meet the business card and stationery needs of the typical small business. They have a large selection of paper, and many of them also provide design services or can recommend graphic designers.

Prepare Standard Forms and Contracts

Now that you have your computer, prepare the standard forms and contracts that you will need: estimate, bid, questionaire for what the client wants, quote forms, model releases, property releases, delivery memos, and so on. You will need them as soon as you get your first assignment, and you should be ready to roll.

Use as a guide the sample forms provided by such professional associations as ASMP http://asmp.org/. Set up each form as a separate file. You can then open the file whenever you need a particular form, save it as a separate job file, and fill in the blanks as required. Be sure to back up the master form files to a storage medium independent of the hard drive.

Set up the Accounting and Recordkeeping System

Now that you have your computer and you have expenses (if not yet any income), you should set up your accounting system to keep track of everything. You should also establish a workflow and filing system to meet all the recordkeeping needs of your business.

I strongly recommend that you purchase one of the small business accounting software packages sold in all

the popular software outlets. It will enable you to track your financials on an accrual basis (maintaining a balance sheet in addition to an income statement and automatically presenting you with information on upcoming payments to be made and income to be received) without requiring you to post present and future cash inflows and outflows to the balance sheet. You have to perform three tasks:

1. Maintain the electronic checkbook, which will write and print checks for you and prompt you to enter deposits, just like your paper checkbook.

2. Generate invoices on the system to be sent to clients. The invoice appears on the screen; you fill in the blanks and print it out.

3. Enter invoices sent to you.

The program automatically makes all the entries on the financial statements, so you always have a full set of up to the minute statements at your fingertips.

When setting up the program, you will be prompted to name the income statement and balance sheet accounts according to your needs.

Another option if you have an aversion to financial recordkeeping is to maintain records on a cash basis, or hire a CPA or accountant. This, too, you can do with accounting software on your computer. All you need to do is use the electronic checkbook: write checks to make payments and enter the deposits of payments received.

To organize the flow of related paper (there is always some paper), keep one box for all bills to be paid and another box for invoices that you have sent out, but for which you have not yet received payment. Stack the bills and invoices in the boxes in chronological order. You will also need a filing cabinet to store your paperwork. The paperwork flow will then be:

1. Incoming bills

 a. You receive a bill. Place it in the box for bills to be paid. Enter into the accounting system if you keep records on an accrual basis. There is no need to enter anything on a cash basis.

 b. When you pay the bill, write the check in the electronic checkbook, send it out, and file the bill under Expenses in your filing cabinet. File all

expenses chronologically using the expense categories you use to file your business taxes (telephone, utilities, office rent, etc.). The accounting software will automatically make all additional entries as necessary.

2. Payments to be received

 a. Fill out the invoice on your computer and print two copies. Send one out and place one in the "Invoices sent out" box. This way you can see at a glance what payments you are expecting (as you become accustomed to your software, you might rely entirely on the "Invoices due" list it provides and do away with the box).

 b. When payment is received, deposit the payment in your checking account, make the

appropriate deposit entry in the electronic checkbook, and file the related invoice chronologically in a single "Income" file.

c. You may also opt to have clients pay in full at the time of services and/or delivery.

It is very important to note that if you want to be a competitive pet photographer, you will need a computer, and maintaining your accounts on it will save you considerable time. However, if you insist on being computer illiterate and wish to track your financials manually, you will find it most easy to do on a cash basis, keeping a manual checkbook and using the box system described previously. You will have less financial information available to you during the fiscal year and will face more work at the end of the year by having to manually compile your financial statements.

The other recordkeeping task you have is to devise a system to keep track of each job done for each client and store all related material, including the actual photographs. Most photographers favor the technique used by many small businesses working on an assignment basis: give each job a number, and maintain a set of informational records attached to that number. Maintain a job log, in which job numbers are assigned chronologically as jobs are received, and reference on the job number of all materials and correspondence sent to clients. Maintain a job file by job number and keep all records related to that job in it: estimates, contracts, releases, expense records, miscellaneous correspondence, photographs; everything. This is your working file, as well as your reference file once the job is completed.

Set up the job log as a matrix (excel would work great for this), with job numbers running down the page and related information running across. The informational records in the job log should include:

1. Client name
2. Subject matter
3. Location
4. Date
5. Product line (take the categories from the business plan and log for the purpose of marketing analysis)

The job log is best set up on your computer as database, because you can then search by any of the information categories. If you want all jobs done for the ABC Company, search the database's client category for "ABC Company."

If you don't want to deal with a database, a spreadsheet program is another option.

Lastly, there is the manual log option. This requires just as much work to maintain as a database and requires more time to search, but it can work quite well for the typical small business.

This taken at F-stop 5.3, 560 ISO, 1/1000th sec.

Join Professional Associations

One of the first things you should do when you begin the process of starting your photography business is join all relevant professional associations. In fact, you should have joined some professional photographers' associations well before you started doing the research for your business plan. If you expect to benefit from the local Chamber of Commerce, now is the time to join.

Set up Insurance

There are basically two types of insurance policies you will need:

1. Liability insurance

2. Equipment insurance (camera equipment, car, etc.)

A single insurance agent might be able to handle all these needs for you, but you should find one who has experience dealing with photographers. Get recommendations from peers and the professional associations to which you belong. Take advantage of less costly group plans whenever you can. If you have employees, you are liable for additional types of insurance. Check with your insurance carrier.

Get Photo Handout Production Underway

As soon as you complete the establishment of your business identity and are ready to begin marketing, you will need photo handouts. You can start designing them any time after you complete the marketing plan and

know who your potential clients are. You should make production arrangements as soon as you know your business name, address, and phone/fax numbers. There is some lead time involved, so time the production carefully to make sure you have the handouts when you are ready to start marketing. Don't forget to design and order the customer response cards to be used in direct mailings along with the handouts.

Begin Developing a Client List and Direct Mailing List

Other marketing tools on which you should get an early start is the client list and the direct mailing list. As soon as your database program is up and running, start building your database. Identify sources of direct mailing lists. Find out how effectively the lists can be customized to your specifications. Establish specifications based on

your marketing plan, and check out what is involved in adding the list to your database.

The actual purchase of any lists has to be timed carefully. You want it to be as current as possible, so you don't want to get it too early. On the other hand, you don't want to hold up the mailing because you got the list too late and are having trouble transferring it to your database.

Finalize Photo Equipment and Supply Arrangements

Have high-quality core equipment and sufficient backup supplies (such as extra memory cards and batteries) needed to complete any job without embarrassment in case of equipment failure, this also includes your post processing software. Don't be extravagant by buying expensive, rarely used equipment. For those needs,

there is always the rental market; identify reliable rental sources.

Select a Reliable and Accessible Photo Lab

The photo lab you use can make or break a job. After you have shot your first assignment is not the time to go searching for one. There is great variation among photo labs in the quality of work, the ability to meet promised deadlines, and the ability to get a complex order correct. Identify the major photo labs in your area and give them all a try. Meet the manager and ask for a tour (most will be happy to oblige, and as a commercial client, you will probably be assigned to a customer representative). Try recommended out-of-town labs or online sources if the ones in town don't measure up. Compare price as well as quality. Select a primary lab, but also line up at least one backup lab. Establish an account if you qualify. Of

course, there are some pet photographers who will be printing their photography on their own printers. If that is the case, make sure your equipment is running smoothly, you have plenty of photographic paper and ink and your printer is calibrated to your desired settings.

Finalize your Portfolio

As soon as your marketing plan is complete and you have clearly identified the target market, it is time to finalize your portfolio. You probably already have a body of work upon which you will be relying for the bulk of your portfolio, but the marketing plan might have identified the need for additional images. Now is the time to shoot them and get everything ready to launch your marketing program. Use a professional portfolio book for displaying your best work to potential clients.

Kyle Richards

Issue a Press Release

When everything is in place and you are about ready to launch your marketing program, it is time to announce your venture to the world. Compose a press release and send it on your brand new stationery. Send it to local, city, and regional papers (include an 8-by-10 glossy photo of yourself), and perhaps even to a select list of potential clients (include a postcard teaser instead of a portrait of yourself).

Hold a Grand Opening Reception

Celebrate your new venture with a grand opening reception. This is an especially attractive proposition if you have a studio, but if you don't, you can rent one for the purpose. Display your work, have promotional

packages available, and scatter your business cards about liberally. Invite any personal contacts and acquaintances you have in the business, as well as your friends. You might even want to invite some potential clients.

Marketing The Business

It is tempting to think that outstanding photographers will sell themselves, but the fact is that without a comprehensive, well-planned marketing effort, even the best photographers won't be in business for long. At the same time, an average photographer who is a skilled marketer can easily do better financially than more experienced colleagues who do a poor job of promoting and selling their services. Marketing is as crucial to the success of a photography business as good financial management.

For the photographer, marketing is essentially the art of self-promotion. A successful marketing program is made up of many elements and requires the application of a variety of skills and techniques. Assessing the chances of success is a big challenge because marketing is at the whim of so many fickle human factors. Some fields of photography require subtlety, while others require a not-so-subtle approach. Marketing costs money; a lot of money. One beginner's mistake is not realizing just how much money a successful marketing campaign can consume and not budgeting enough to get a credible effort off the ground. Another pitfall is optimistically pouring a great deal of money into the wrong type of campaign and ending up with a devastating, expensive fizzle.

How do you find the fine line in between? Many novice marketers make the mistake of using their own

perceptions and values regarding what potential clients want and should want. They are disappointed when they realize that their own preferences are not generally shared by their clientele. Yet there are well-established marketing principles and techniques derived by the profession from decades of experience catering to clients' demands. Why not minimize the risk of costly marketing mistakes by benefitting from these principles and techniques to develop and implement your marketing program?

The marketing process is really quite simple and doesn't take much more than a good dose of common sense. You have to do market research to establish that a sufficiently large market exists for your product. You have to price your product to be competitive in the marketplace. You have to identify the customers to whom you will market the product. This pool of

customers should be sufficiently large enough to yield a sufficient number of assignments to provide you with a living. You have to devise a variety of innovative marketing approaches to create a flow of client inquiries, and then convert those inquiries into sales. Finally, you have to maintain an ongoing marketing program to ensure a continuing stream of assignments and develop a core clientele to sustain your business.

Consider pet related businesses and genres to make contact with and network. These might be:

 a. animal hospitals and veterinarians

 b. pet groomers

 c. pet breeders

 d. people who show different types of animals

 e. pet sitters

 f. pet stores

Attend some dog, cat, horse (or whatever animal you may want to specialize in) shows, you may be amazed at the contacts you meet there. Some pet photographers set up booths at these shows for photography services right there on the spot with mini-studios.

Within this framework, marketing programs can be broken down into a number of distinct elements:

 Marketing information

 Reference sources

 Pricing

 Direct mailing

 Advertising

 Public relations

 Networking

Each element of the successful marketing program will be explained, including general strategy, techniques, practices, and skills.

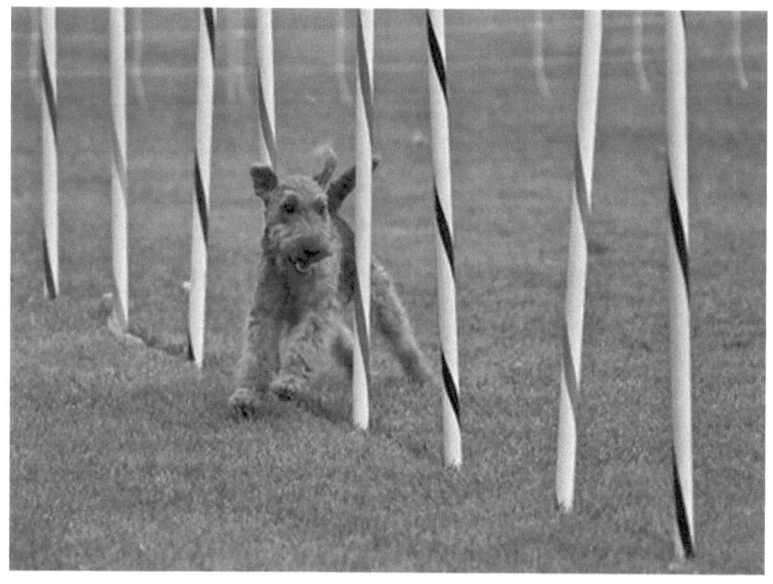

This taken at F-stop 5, 400 ISO, 1/1250th sec.

Market Information

Developing solid information about the target market is the first step of every good marketing program. Market information means the market size, sales potential, an assessment of your competition, and information on pricing and market practices. Bear in mind the chicken

and egg argument: what comes first, the product or the assessment of market demand for various products? Remember, you shouldn't be in this business if you are not happy doing the work that you choose, so define your product first. But what you choose to offer might have to be substantially revised in view of market demographics. Revise if you must, but don't lose sight of your goal of personal satisfaction and end up with just another boring job.

Reference Sources

There is a whole industry out there dedicated to providing information on where to get information. It is the reference industry, and its publications are found in your local library's reference section. Dreary as it may sound, time in the reference stacks is well spent and an excellent starting point for gathering market information.

Reference sources can be used to provide direct information about the photography business. These sources will give you a laundry list of information sources relevant to pet photographers.

Professional Associations

They are an excellent source of market information. Providing such material is, in fact, a main reason for their existence. The type of information you can typically get from associations includes market size, guidelines on estimated market size required per photographer, professional practices, and marketing guidance. Some associations even provide directories of major buyers of photographs, such as ad agencies and stock houses. Every association has a directory of members, many of whom are willing to network. Many associations also commission market studies, which can be a gold mine of

information. Some associations also put on marketing seminars.

Chambers of Commerce

The local Chamber of Commerce in a pet photographer's territory is a good source of information on potential clients. Many member firms and organizations have photo needs. Chamber activities are an excellent way to gain an introduction and pave the way for assignments without having to resort to "hard sell" tactics. Chambers of Commerce sponsor numerous community events that can provide even more leads. Chamber of Commerce member directories can also be a good mailing list foundation.

Newspapers

The newspapers serving your community are a surprisingly good source of market information. They are loaded with news items that alert the vigilant photographer to potential assignments. New businesses opening in a community might be indicative of photo needs. The arrival of a big new employer in town might prompt people to move to your community, increasing your potential market.

Announcement of upcoming conventions, sporting events, or other special events can lead to assignments. The list of businesses advertising regularly in the local paper can be a good source of additions to your mailing list. Making contact with various animal breeders in your area could be good as well, as many of those new pet owners might enjoy professional photos of their brand new pets as babies. Reports on economic conditions and

trends in your community can give you some indication of whether or not to expect your own business volume to grow.

Photographers

Many pet photographers are willing to share market information on their industry and personal experiences, especially if the person approaching them is not going to be in direct competition with them. If you are planning to work in a particular community, contact other photographers or pet photographers in nearby communities. Another good idea is to talk to photographers whose careers have moved beyond the stage where you are and who might be willing to share their experiences with someone on the way up. Photographers love to attend professional gatherings and seminars, where there is great willingness to share experiences and opinions freely. Eventually these

contacts can lead to sound personal friendships and a real network of information.

Pricing

Pricing is a crucially important element of the marketing program. If you price yourself out of the market, your entire marketing effort will be a big flop no matter how good your work is or how convincing you are. If you price yourself too low, not only are you losing money, but you are also hurting the entire profession by giving clients reason to expect services for prices that are unprofitable. Established photographers are perpetually concerned that inexperienced newcomers will try to compete on price and will end up ruining the market for everyone.

Remember two guiding principles as you set out to price your products. First, you are running a *for profit* business, not a charity. The most important point here is this: income minus expenses equals profits. You simply have to charge a sufficient amount of money for your work to make a reasonable profit.

Generally free promotions for a start up is not a good strategy. As a principle, people do not properly value what they get for free, and most times freebie promos do not convert later into paid jobs.

Second, it doesn't make economic sense to compete on pricing. Why should you charge less than what is being charged for the same work by other pet photographers? If you cannot get work at that price, it most likely means that the market in which you wish to compete is

saturated. If, in response to not getting a sufficient amount of work, you undercut the competition's price to get market share, you will just end up torpedoing everybody's livelihood. You are better off carefully doing your market demographics analysis and "local going rate" homework and establishing yourself in a market that has a sufficiently large pool of potential clients to support you. Generally, try to compete on service and quality of work, not on price.

There are two basic elements to pricing: pricing technique and the actual amount charged within the framework of the applicable technique. Together, they can be thought of as pricing standards. You should consider pricing standards a point of departure for setting your own pricing rather than rules to be rigidly followed. You will find that there is often room for departure from the norm. Skillful negotiation and a

creative application of pricing techniques might create good opportunities to increase the pricing of particular products and services beyond the ballpark standards.

How do you price your products and services?

So what do you make of this smorgasbord of pricing information? Where do you fit in? It all comes down to a pricing strategy designed to keep you in control of determining how much you are going to get for your work. This is based on your analysis of what your work is worth in comparison to the other work being offered.

On the one hand, there is the economic cost of producing the product, including a reasonable margin for making a profit beyond total expenses. On the other hand is

supply and demand in the market, which often has little to do with the economic costs of producing individual images. Some pet photographers charge a flat 'photo setting fee' which is charged on the time the photos are actually taken. Some choose not to do this and their profits come only from the sales of the photographs. This is entirely up to you.

Regardless of the value you place on your photography skills, in this example, the total sum of such skills on the market has produced a supply of the product that outstrips demand. Therefore, the price the market is willing to pay for the product falls. What is the rational response of the photographer? It is to lower the price of his or her product, but only to the point at which his or her minimum profitability goals are still met. If the price the market is willing to pay falls below minimum profitability goals, the only rational course of action is to

exit the market and concentrate on other, more profitable markets. This is an economic reality many pet photographers simply refuse to understand. Demand for such a specific talent in pet photography has to exceed supply for compensation to approach anything close to what the photographer believes is fair. The only business-minded solution is to work in those market segments of pet photography where that is the case.

In spite of the many branches of photography, the strategic approach to pricing is quite universal. When setting up a pet photography business, you can use the following approaches below:

1. Ascertain that a market exists.

2. Assess the market's size and compensation structure.

3. Determine your profitability objectives and the cost structure of each product you are offering (including compensation for your time).

4. Determine the minimum price you have to charge per product (including compensation for your time) to meet your minimum profitability objectives.

5. Compare your minimum price to the range of prices on the market.

6. If your minimum price is below the market range, increase your price immediately to market level.

7. Maximize your price by developing credible arguments to convince buyers that your product's value is at the high end of what the market has to offer.

9. Do not offer products that do not meet your minimum profitability objectives.

Beyond developing an understanding of each product's cost structure and establishing the prices you should charge, there is one more pricing concept you should understand to maximize the prices you do charge: there are no standard prices per job because each job is unique.

Having established that there is a market with an acceptable pricing structure, the next marketing task is to actually reach specific clients and convince them to give you a chance. The most common ways to reach potential clients are direct mailing, advertising, social media, public relations, and networking.

Direct Mailing

It has always been one of the best initial points of contact with potential clients. With the advent of

personal computers, it has developed from a fairly inefficient correspondence effort with relative few potential clients into a sophisticated marketing tool. It utilizes massive, carefully developed, and regularly updated databases to launch precisely targeted and timed mass mailing and closely scrutinize the results. The key success factors of a direct mailing effort are:

1. Reaching the right audience.

2. Reaching the appropriate decision makers in the targeted organizations.

3. Effectively differentiating your promo material from others' to convey that you can provide better value for the client's money than the competition.

4. Diligent, effective, and unceasing follow-up to keep your chances alive.

The mailing list is a peculiar animal, and its economics need to be understood. Returns from even the most successful mailing are typically low. A 0.5% response rate is often considered a good return on an initial list, so having a high volume of names is a very important consideration. A 0.5% response rate for 5,000 names is only 25 responses. However, one good assignment out of those 25 responses pays for the mailing, and then you are ahead. Experience shows that the subsequent additional return on additional mailings to initial responders is much higher. These responders will in fact form the core of your ongoing profitable client list.

Here's the way to approach the mailing list from a cost-benefit standpoint:

1. Assess what it will cost to acquire the list and produce and mail the promo materials.

2. Assess how many assignments will pay for the mailing to get an idea of the break-even point of the mailing.

3. Set a goal for sales over and above your break-even point to make the mailing worthwhile in terms of profit generation versus time and effort.

4. Do the mailing and monitor the results. Revise your mailing strategy as needed for subsequent mailings.

If properly targeted and structured, direct mailing can be a steady source of repeat business. If improperly implemented, it can be a disappointingly expensive marketing fiasco, so it is very important to get it right.

Building the Mailing List

There are two ways to develop a mailing list: you can buy names, or you can do your own research and compile your own list. Pet photographers who make serious use of mailing lists rely on both methods. They buy a set of carefully chosen names to start their initial list, and they add potential and actual clients' names as they encounter them.

Mailing lists are available from list brokers and are priced per name (or some variation, such as per 1,000 names). Conscientious list brokering has developed into a fine art. Successful brokers maintain vast databases and have developed techniques for making customized lists to meet a particular list buyer's needs and maximize the chances of success. They will provide comprehensive information on their databases and the available

selection criteria and will work with you to customize your own selection criteria. You can do a web search to find these brokers.

The selection criteria can be just about anything. There are no hard and fast rules. Ultimately, it is up to you and your common sense, tempered by advice from a knowledgeable list broker. A good place to start is to define the ideal client and seek an initial list of names fitting this description. Here is where good market research comes in. If you've done your homework and ascertained that there is a demand for your work within a group of potential clients fitting a particular description, then it stands to reason that the more names you get that fit your description, the greater your chances of getting a response.

There are many ways to set criteria. Some typical base criteria are:

1. Type of business

2. Main products of the business

3. Main markets of the business

4. Stated photography needs of the business

5. Dollar size of the business (annual sales, assets)

6. Geographic location of the business

Based on your market survey results, the next step is to define your selection criteria.

It used to be that a list you bought consisted of a set of address labels you slapped on your outgoing material, and that was it. Today, you should get a lot more

demographic information on each name, and the list should be in database format on a disk ready to be put into your computer's database program. This allows you to use the list in many ways, allowing you to customize your mailings by whatever subcategories are appropriate and enabling you to perform mail merge functions to customize the cover letter and other material in each package. In essence, you should be buying a database, not just a list of address labels.

One of the most important considerations in buying a list is ascertaining whether it includes the names of all the buyers of photographers within the listed organizations. A list that doesn't include photo buyers is practically useless because it is very unlikely that the recipient will take the trouble to forward your unsolicited mailing to the buyer.

There might be restrictions on how many times you are allowed to use a particular set of names. This is a reasonable practice, similar in concept to the restricted use of photographs. To control unlimited use, list brokers lace their lists with addresses that claim to be companies, but are in fact brokers, immediately alerting them to unauthorized additional use of a particular list. Some list brokers get around restrictions and the potential hassles of unauthorized use by offering reasonably priced periodic updates to initial lists.

All responses to your mailing list should be identified in your database. As you come across potential clients, they should be added to your database. During slow periods, you should spend some time actively identifying and adding potential clients to your database. Be sure to include the names of all photo buyers within the organizations you add.

Kyle Richards

What Do You Send Out?

Mass mailings are unsolicited mail; therefore, the recipient's temptation to toss it in the wastebasket is great. Now's the time to let your photographs sell themselves, to have them distinguish you from the herd. The centerpiece of all mailings should be a taste of your portfolio. The photographs should be stunning, your best work, and they should be representative of the typical needs of the recipients. Beautiful photos tend to be kept by anyone receiving them, and photo buyers will retain them and remember them even if they don't have a specific need.

The centerpiece of your package should be some striking collage of your best work. Post-card size prints have also become very popular for main mailing packages, as well as for follow-up mailings. They are relatively inexpensive

to produce and can be mailed directly as postcards in addition to being the centerpiece of a package. Most photographers have a series of cards made up in a related format for maximum flexibility. They include several cards in each package mailing and might periodically mail individual follow-up cards between package mailing cycles.

A personalized cover letter on eye-catching stationery should briefly convey the following information:

1. Who you are.

2. Why you are different from other photographers.

3. What you can do for the recipient.

4. How your experience (past jobs, awards, professional training, exhibits) proves that you can deliver what you promise.

Make it Easy to Respond

A key element of any mailing is arranging for the recipient to respond. This is typically accomplished by a well-designed response card. Give a call to action, maybe it is to give you a call, visit your website or facebook page whatever you are after, just make it simple and clear.

Follow-up Techniques

A direct mailing effort is unlikely to be effective if it is just a single mailing. The initial mailing should be followed up by additional periodic package mailings, as well as smaller postcard "reminder" mailings in between to keep your name alive, you are branding your business.

Responses to your mailings should be answered promptly and professionally. Upon receiving a response, you transition from marketing to selling. It is now your job to convert the contact into a sale – an assignment. Responses should also be immediately tagged on the database and subjected to periodic detailed additional mailings.

Listings in Directories

These are proverbial lists of business names, addresses, phone and fax numbers, and perhaps areas of specialization. While not particularly effective as a main source of advertising, listings are so inexpensive that it would be foolish for a photographer to ignore them. Most professional photographers' associations publish directories of their members, and the cost of being listed is included in the annual membership fee.

There are ways to distinguish yourself even in the bland world of listings. A trade name beginning with one of the first few letters of the alphabet will get you near the top of the list. A trade name carefully chosen to indicate specialization can help. For a small extra fee, most directories will list you in bold type, an effective way to catch a roaming eye. Some directories also allow a listing of specializations that can be used cleverly.

Social Media

Set your business up with a facebook account, twitter, pinterest, linkedin and other other social media venues you desire. Try to network with pet owners in your area. Perhaps you can post pet care tips or other information valuable to pet owners to help build your online presence. You may want to start your own blog as well.

How to Start a Pet Photography Business

You can also purchase facebook ads or google ads for your pet photography services, having them service to only people in the area that you service. The fact that it can be targeted by geographic location and even to only those interested in pets, can make this a very powerful way to reach clients.

This taken at F-stop 5.6, 1600 ISO, 1/125th sec.

Kyle Richards

Public Relations

Public relations is soft advertising. Its goal is to maximize an organization's positive exposure to the public by publicizing the organization's activities, accomplishments, and services to the community. Public relations conjures up expensive campaigns by professional promoters, but for the photographer willing to self-promote, public relations will amount to a healthy dose of free advertising and branding awareness.

The trick is to identify or deliberately create any newsworthy item in the photographer's life that can be linked to his or her photography and place it in as many publications and other media outlets as possible. The main vehicle for public relations information dissemination is the press release. It is a timely and concise announcement of a newsworthy item followed by

a summary background paragraph on the photographer. It is issued on business stationery and sent or faxed to local, regional, and national newspapers and magazines. Press releases are unsolicited and are used at the recipient's discretion. More often than many photographers think, even marginally important items are used because publications are always on the lookout for interesting filler material.

Typical newsworthy events that can be used for public relations purposes include:

1. Opening a new pet photography business

2. Expanding a pet photography business

3. Relocating a pet photography business

4. Receiving an award

5. Speaking at a meeting

6. Teaching a course or program

7. Participating in an exhibition

8. Providing community charity work

9. Receiving a professional qualification

When sending press releases to publications that carry photographs, it is always a good idea to include an 8-by-10 glossy photo of yourself, or a digital file of same.

One successful public relations tactic is to provide advance notice of upcoming events and convince news reporters and journalists to write news items or feature stories on them. Another good option is to convince magazines to profile you and your work. The possibilities are as endless as your imagination.

Networking

One of the most effective marketing tools is networking. Some people are natural at this, and there is nothing any book can teach them that they don't already know about chatting up the right people, pumping them for information with discreet charm, and following up every lead. However, most of us don't find it easy to network. We feel we are forcing ourselves upon our potential sources of information. This attitude is wrong for the simple reason that our sources of information also want information from us! It is a two-way street; a deal, fair and square.

The best results from networking are obtained if you can create the impression that you can be of some help or provide a service in return. The exchange doesn't have to be simultaneous. It is enough for the people giving

you information to know that they can call you at some point when they need something and you'll do your best to help. Information can also be bought.

Perhaps the local veterinary or animal hospital will allow you to leave some business cards or a flier in their place a business. In return, you could pass their contact info on to your clients when needed.

See if there are any local pet sitters in your area. They also may be willing to recommend your services to their clients and vice versa.

Similar to public relations opportunities, networking opportunities can be made use of as they present

themselves during the normal course of business or can be deliberately created.

Here are some favorite examples and techniques:

1. Ask a client or potential client about other potential clients or market information. Never forget to do this during client contact.

2. Attend photographers' seminars, talks, or other events.

3. Attend a client's events or conventions and discreetly introduce yourself as the client's photographer (this needs the client's permission first).

4. Belong to the same business, social, and civic organizations to which your clients or potential clients belong.

5. Periodically call your clients or potential clients (once you have established a rapport) explicitly to network, not to flog an assignment. You have to have something specific to start with, and then you can steer the conversation onto the related items of interest to you.

6. Benefit from the natural development of close personal friendships with other photographers, photo buyers, and editors.

7. Periodically hold an open house in your studio for your network.

8. Never be shy about promoting yourself. Be ready at all times with a well-rehearsed, concise story of who you are, what you do, and how you can be of assistance.

9. Always, always exchange business cards with new contacts.

10. Always, always follow up leads promptly and go to great lengths to keep them alive.

11, Party, party, party (with the right people)!

Again, the list of techniques is limited only by your imagination. If you have a really hard time networking, make it a personal goal to place one networking call per day, and stick to it. You'll soon get the hang of it. Some photographers have the opposite problem: they get so involved with networking that they have practically no time left to work.

Running The Business

The grand opening reception is over, it is Monday morning, and it is your first official day on the job in your own business. It is make or break time.

Launching the Marketing Plan

The first order of business is to launch your marketing plan. You will spend most of your initial time drumming up assignments. Depending on your target market, you'll be splitting your time between your direct mailing effort and calling on an already assembled short list of likely customers and developing your social media presence. As the direct mailing begins to get results and the client response cards start coming in, your calling activities will increase further.

If you are doing a mass mailing, write your marketing letter, get busy with your database and mail merge files, assemble the mailing, and ship it out. But how do you send it, expensive first-class mail, third class, or bulk? First class does make the best impression because it is more urgent and personal, but it is expensive. On a mailing of 4,000 pieces, the difference can be several hundred dollars compared to third-class or bulk mail. Bulk is the least expensive, but it requires a permit from the post office, a minimum number of pieces must be sent, and the mailing has to be sorted a certain way. Ask your local post office for a bulk mailing information kit. For the first round, you might want to use first class mail. You can experiment with other options on subsequent mass mailings.

Along with the mass mailing, send out packages to your preassembled "most likely" list, and start calling on

them. Send a small number of packages at a time to give you a manageable calling schedule.

The Transaction Cycle

Whatever it is that gets your foot in the door, before you get an assignment, you have to make the sale. Then comes the fun part, the photography, then filling your customer's orders from the photo shoot, running around to labs or ordering prints, delivering the finished product, and getting final payment.

1. *Selling*

> Selling is a distinct, final stage of marketing. It is your face-to-face chance to convince the potential client to work with you. Marketing research gets you to the right clients, and marketing packages

pique their interest. Selling starts the minute you make the first personal contact and begin the job of convincing them to give you a hearing.

Some people are born to sell. They feel completely at ease with potential clients, make just the right amount of small talk at the right time, instinctively spin out convincing arguments of why they have more to offer than the competition without bad-mouthing the competition, and get a real high from closing the deal. For others, selling is the most dreaded part of the job. But the fact is that selling techniques can be learned by anyone, and with practice, selling becomes much more natural for everyone.

Most Sales 101 courses will tell you that there are four distinct stages to selling: initial contact, the sales presentation, closing the deal, and follow-up.

a. Initial Contact

The initial contact is a telephone call following up on the marketing package you just sent. The package is the excuse for the call. Just calling out of the blue and saying that you are Kyle the photographer and you want to show pictures will rarely get you anywhere. In your promo piece, your pictures have already done the talking. If they are up to snuff, most recipients will feel both comfortable talking to you.

Keep the conversation brief and to the point. "Hello, I'm Kyle the photographer. I just send

you an information package on my work, and I would really appreciate an opportunity to show you my portfolio and discuss with you how I can help you meet your photo needs," or something along those lines. Sound enthusiastic, but don't be pushy. Aggressive sales tactics are more often than not counterproductive. If there is any merit to your promotional material, you should get a sympathetic hearing.

If you are told to come on down, great. Grab your portfolio and get going. If you are told that there are no immediate needs and no point in meeting, you might ask for a strictly informational meeting. Say that you are just starting out, and if it wouldn't be too much of an imposition, you would really appreciate 15 minutes to get the benefit of the person's

experience or opinion in the field. Flattery can work wonders. If it is really a "no go," ask for the names of anyone else that person thinks might be interested in your type of work.

b. *The Sales Presentation*

If you make it to the presentation stage, you are doing your job, and now is the chance to do it even better. Any presentation has to have a clear sense of purpose. Determine in your own mind what the primary objective is and what additional objectives you would like to accomplish. Write them down and devise a presentation plan.

People inexperienced in sales always worry about what they are going to say. The small talk

up front is always useful to create an easy atmosphere, but don't worry too much about it, and especially don't overdo it, because it starts to smack of wasting time.

When it comes time to get down to business, be ready with a practiced pitch. Use the soft-sell approach. View the presentation as a two-way street. You are there just as much to learn about the prospective client as you are to present yourself. Briefly explain who you are, what your area of specialization is, and get right into presenting the portfolio. Then you can transition into asking for the prospective client's reaction to your work and questions about how photo needs are handled. Listen as much as you talk. Feel free to take notes. This is your opportunity to get firsthand information on your

market, which will be very useful in selling to other prospects. Make good use of your chance. Demonstrate by your responses that you understand what is being said, and gently explore not just immediate possibilities, but also long-term opportunities.

c. *Closing*

Sales calls run their course quite naturally, and even the novice can sense when it is time to bring the session to a close. The important thing about closing is that it should clarify and sum up whatever opportunity might have come out of the meeting. If an assignment is not the end result, and most often it will not be at the end of an initial call, then it is crucially important to secure the right to call again. If the prospective

client keeps a list of preferred photographers, it might be appropriate to ask if you could be included, or what you need to do to be included.

What if you are asked to leave your portfolio? By all means, leave it, but not for too long, implying that you have places to go and people to see. Set a firm date for retrieving it (in person), which gives you an excellent follow-up opportunity.

Before you leave, ask for the names of anyone else they might know, that might want to see your service. Often this will lead to several contacts, and you have an automatic in by being able to say that "So and so thought you should see my portfolio."

d. Follow-Up

It is vitally important to follow up a sales presentation because neglect can derail all the accomplishments of the meeting. If an assignment is in the offing, keep after it to nail it down. If a longer-term relationship is suggested or if your work was liked, plan the next call. A brief personal thank you on a postcard not previously seen by the prospective client is an excellent idea.

At first, there will be some rough edges, but soon you will find that sales calls settle down into a pleasant, or at least tolerable, routine. You will without a doubt encounter an occasional jerk who goes out of his way to make you feel miserable, and then it is very important

to maintain your self-confidence. Recognize that the problem is not you and quickly move on without missing a beat. As you begin to develop personal relationships with some of your clients, you'll look forward to seeing them, and you'll become part of a network that will probably generate more work than all the cold calling you did to get there.

This taken at F-stop 5.6, 160 ISO, 1/320th sec.

2. *Performing the assignment*

>This is what you do best; this is what being in your own business at all about. Here are some points to live by:

>a. Be very careful to understand exactly what the assignment is, what the client wants, what the finished product is to be, and what the deadline is.

>b. Take great care to plan the sequence of the job and the amount of time required to complete each phase. This is the only way to ensure that the deadline expectations are realistic. Write out a detailed plan for each job the first few minutes, and always do one for complex, lengthy assignments.

c. Take great care to think of every expense; estimate every expense as accurately as you can. Decide what happens if additional expenses are necessary.

d. Clearly establish what documentation the client requires of expenses (this might be very detailed for both financial control and tax reasons).

e. When it comes time to shoot the assignment, make sure you have all the equipment and film you need, including contingencies for equipment failure. Use an assignment checklist to assemble everything before leaving for the location.

f. Leave ample time to obtain special equipment rentals and models.

g. Don't run out of steam after you've had your fun shooting and reviewing the results. Deliver the final product on time and on budget.

h. Always use a major courier or bonded messenger service to deliver the finished product (charge it to client), deliver in person, or have your client pick up at your business.

3. *Getting Paid*

Be firm on payment terms. No money, no pictures! It is as simple as that. Get the agreed advance before you start a job, and invoice promptly for the balance. Use the advance to cover all of the expenses of doing the job so that you will not be out of pocket if you run into problems with the balance. If the expenses on a particular job are so

high that they exceed the customary advance, get an additional advance to cover them.

As a rule, collect any balance due from smaller clients when you deliver the finished product (cash on delivery). Bigger companies (larger agencies and corporations) expect to be billed for the final balance due, which is essentially extending unsecured credit for 30 days (the usual terms of invoices).

Don't be understanding about delays in payment. Call requesting payment, send past due notices promptly every 30 days, and charge an overdue penalty charge. If a bill becomes 90 days past due, send a demand letter, politely stating that if payment is not received within 15 days, you will have no choice but to seek legal remedies. A legal

demand often flushes out a payment. If it doesn't produce results, turn the case over to a collection agency. They charge a percentage of the amount they collect, payable upon collection.

4. *Evaluating Performance*

You should regularly monitor how your business is doing. It is a pleasure to see that you are doing better than expected. On the other hand, you need to know sooner rather than later if things aren't going as well as they should be. Performance measurement is also important to see if the nature of the business (types of assignments, rates per assignment, and so on) is as you expected. You will gain a better understanding of the business and will be able to make more reliable adjustments

for subsequent annual business plans if you do periodic performance assessments.

The most common monitoring technique is to measure financial performance. Periodically, it is worthwhile to evaluate how well your marketing effort is going by putting together a marketing report. Neither task is as onerous as it might sound, especially if you use a computer.

a. *Financial Reports*

> There are no special reports to generate to measure financial performance. All you really have to do is look at your cash budget, income statement, and balance sheet at the end of each month.

By comparing the actual monthly cash budget to the planned monthly cash budget, you will instantly have a pulse for the business. The income statement and balance sheet will tell you at a glance if you are accumulating capital or depleting it. As the year progresses, comparisons to the previous months' results will give you an interesting insight into trends.

If you are keeping your accounts on a cash basis only, most accounting software will still provide the cash budget and income statement. If you rely on the manual checkbook basis of Stone Age accounting, you should have a bookkeeper or accountant compile at least an income statement at the end of each quarter.

b. *Marketing Reports*

The marketing report is simply a record of the actual jobs booked during a given period. It is essentially the job log for the period. Are you getting assignments at the rate anticipated, and are they the kind of assignments you planned to get? How profitable is each assignment in comparison to your plan? You need not review marketing results more often than at the end of each quarter.

If you are keeping the job log on a database, it is easy to create a marketing report by printing out the relevant section. If you are keeping a manual log, just review the relevant section; don't bother with a

separate report. In either case, compare your marketing results to the marketing plan.

4. *Keeping Up with Administration*

If you have set up the business properly, its administration should not be an overwhelming task. It is important, however, to make a conscious effort to keep up with administration, especially for photographers who are naturally inclined to ignore it. Make a list of all the administrative tasks you have to do, estimate the amount of time they require, and set time aside in your schedule to do them. A typical list of tasks might look like this:

a. Bill paying (weekly)
b. Invoice preparation and mailing (weekly)

 c. Mailing list database maintenance (biweekly)

 d. Job log database maintenance (weekly)

 e. Financial statement review (once a month)

 f. Marketing results review (once a quarter)

 g. Direct mail preparation

 h. Social media updating

On such a schedule, you should probably set aside one afternoon a week or two half-afternoons a week to do all the administrative tasks except the direct mail preparation and see how it goes.

Direct mailings are a major, time-consuming effort. To handle them, set aside a specific time when the mailings need to be done. The trick to effective administration is not to fall behind.

Some people also have trouble keeping receipts, bills, deposit slips, and the like, in order until they need to be handled. Make it easy on yourself. Put everything into one file as you come and go during the day, then sort it all out during your scheduled administrative time. If you put off administration, the pile will become overwhelming. Admit it if you are a totally hopeless administrator and avail yourself of a bookkeeper's services once a month before it is too late.

5. *Don't Let Up on Marketing*

> When success comes, it is tempting to ease off marketing and spend all your time on the assignments that your initial efforts brought in. This is a common reaction and a big mistake. The pipeline of assignments can quickly dwindle and even dry up if you do not continue to spend a

considerable amount of your time drumming up additional business. The marketing program must be ongoing and systematic. Targets for numbers and types of assignments must be maintained, and every attempt should be made to increase the volume of business. Any fall off in business volume should be recognized early, the reasons identified, and corrective action taken before the business suffers.

Over time, the photographer will reach a saturation point in the number of assignments that can be performed per year as a one-person show. At that point, a choice has to be made. The business can be expanded by hiring a promising photographer to work with you on bigger jobs and take the overflow under your close guidance, or you can choose to hire a full time administrator to do all the non-

photography related tasks. In either case, your systematic marketing effort must continue.

As your business matures, your marketing strategy will change in that you will begin to develop a core clientele from whom you will get steady business. You will have to split your marketing time between cultivating these existing clients and searching for new clients.

Along these lines, you should also refine your database by flagging core customers (add a separate core category). While the initial mailing and cold calling will most likely yield a percentage return in the very low single digits, repeat business from core customers is likely to run considerably higher. To maintain the relationships, you might

want to make periodic special mailings to core customers only.

Your existing client base will form a valuable information and referral network, making the search for new clients easier. But you must continue to keep a clear marketing focus, track marketing results, and invest a lot of time in marketing.

6. *Time Management, the Great Juggling Act*

So how do you juggle all these tasks? Be persistent and have patience. Here are a few tips:

Make a daily to-do list. Assess everything you need to get done each day, make a list, and work your way through the list.

Prioritize the to-do list. Mark as "critical" every item on the list that absolutely has to be done by the day's end, and do them. Transfer any uncompleted item to the following day's list (eventually each item will move up to "critical" and will get done).

Tackle and complete one task at a time. A sure way to let things get out of hand is to dive into a number of tasks at the same time without finishing any of them. If you start something, make sure you have enough time to finish it. There will be times when you will have to do several things more or less at the same time, but focus on finishing one task after the other in order of priority. You'll be much more productive than if you keep scurrying back and forth between them.

Avoid making unnecessary telephone calls. Some people have a tendency to focus on mindless, low-priority tasks, and then they wonder why they are falling behind when they are working so hard. If you run out to the photo store three times a day, make two trips to the post office, and spend the rest of the time on the phone telling a friend how hard you are working, you won't get much done by day's end. Combine errands and cut them to a minimum.

Unproductive telephone calls can be both a temptation and a real nuisance. Some people are happy to talk forever, and you might be too, but you must keep moving. Good ploys are, "I have someone in the studio," or "I have to go out on an assignment," and so on.

Observe the daily patterns of your energy levels and tackle tasks accordingly. We all have the best times and slow times of the day. Note when you are at your best and try to schedule demanding, creative work for those periods. Schedule dull but necessary tasks like administration for your lethargic, low-energy periods.

7. *Work Habits, Professional Demeanor*

A photographer's professionalism has a lot to do with being chosen by a client. There is both form and substance to a professional demeanor. Form is important, because rightly and wrongly, many clients are greatly influenced by that all-important first impression created by the photographer's dress and general appearance. Photographers should appreciate that because they are the sellers

and the clients are the buyers. The more they meet their client's expectations, the better their chances of getting an assignment.

It is best to tailor your general appearance to what is expected by a particular client. The dress code of a progressive ad agency is quite different from the dress code of a conservative corporation. Research the general expectations of your various potential clients and dress appropriately.

More important in the long run than form is substantive professional conduct. Again, bear in mind that you are the seller, so you have to conform to the clients' expectations. The more professionally accommodating you are, the more enduring your relationship with your client is likely to be. Many of the following suggestions are self-

evident, but you would be surprised how often business people, including photographers, have trouble remembering them:

1. Always deliver what you promise.
2. Don't exaggerate your abilities.
3. Meet deadlines religiously.
4. Keep professional hours.
5. Always be on time for appointments.
6. Be reachable at a professional location.
7. Return all phone calls and return them promptly.
8. Respond to client response cards and unsolicited expressions of interest immediately.
9. Always be constructive, positive, even-tempered, and fair, even when things aren't going your way.

8. *Choosing Accountants and Lawyers and Dealing with Them*

Accountants and lawyers are an invaluable source of specialized professional services, and managed properly, they can save the photographer a lot of money and grief. How do you know if you are filing the proper tax forms, maintaining the proper financial records, making the right legal choices, protecting yourself sufficiently from liability, and operating your business within the bounds of business and other laws? Just as most accountants and lawyers turn to photographers when they want a professional portrait, so should you turn to them when you need their professional services.

Be aware that many accountants also act as general business consultants and are able to

handle routine legal tasks such as company formation. Also bear in mind that laws and regulations vary from state to state, so hire a lawyer licensed to practice in your state.

There are two perceived problems with accountants and lawyers commonly raised by photographers wary of them: their charges can escalate dramatically beyond an affordable level, and it is difficult to tell if you are getting the services of one familiar with and experienced in serving the needs of photographers. Both issues can be easily handled if you follow a few simple guidelines:

a. Be in control. You control the relationship. You have to let the accountant and lawyer know exactly what you want and what budget you have in mind.

You should expect to be presented with options, and you should be the one making the ultimate decisions. Just as you never cease to market yourself to your clients, so too will accountants and lawyers try to convince you to use more of their services. For that, they can't be blamed, and it is up to you to say no.

b. Get referrals. Choose an accountant or lawyer only on the recommendation of other photographers who have used them with good results.

c. Check them out with the authorities. Before signing on an accountant or lawyer, check with government and professional organizations to see if there have been any complaints against them. The Secretary of State, consumer affairs

departments, better business bureaus, and state bar associations are all sources of information on complaints and other professional problems.

d. Conduct an consultation (for which there should be no charge). Just as you are interviewed before being given an assignment, so should you discuss with prospective accountants and lawyers your needs and how they can meet them. If they want to charge you for this initial consultation, walk out.

e. Ask for a price estimate of each specific service. Ask up front what a particular service will cost. Some services are provided on flat rates, but accountants and lawyers frequently charge by the hour. Ask how many hours a task will take, and make it clear than any additional hours have to be approved by you.

Taxes

Taxes are a source of revenue for federal, state, and local governments. The most serious offense is a failure to report all income. The expenses and deductions that you claim when calculating net taxable income can always be argued about in good faith (unless there is outright fraud) and adjustments made. But if it turns out that you didn't report income you should have, you will be faced with fines and possibly even more severe penalties.

There are actually several types of taxes for which your business is liable, all based on levels of income. If you have no employees, you will have to report and pay:

1. Federal Income Tax
2. State Income Tax
3. Social Security Tax

4. State and Local Sales Tax

5. Other Local Taxes

If you have employees, you will also have to report and pay

1. Federal income taxes withheld from your employees' pay (and sent by you to the IRS)
2. State income taxes withheld from your employees' pay (and sent by you to the state tax authority)
3. Employee social security taxes (FICA; withheld and sent to the 4. Social Security Administration along with the business's contributions to the employee's social security benefits)
4. Other employee related local taxes

The basic financial record that forms the basis for tax reporting on your employees is the individual payroll record. You can see once again why hiring independent

contractors might be the better way to go to some circumstances.

Note that the tax authorities require that tax payments be made during the year in proportion to the income earned during the year, not just in one lump sum at year's end. For employees, the employer takes care of making tax payments during the year based on the level of withholding they request. But as a self-employed person, no one withholds taxes for you. Instead, you have to estimate your personal federal income tax liability quarterly and send in the quarterly estimate (Form 1040ES) along with a check for any payment due. If you have employees, you must also send in an Employer's Quarterly Income Tax Return.

Annually, you need to file the business's tax statement. There are different federal filling forms for sole proprietorships (Form 1040 Schedule C), partnerships

(F0rm 1065), corporations (Form 1120), and S corporations (Form 1120S). You also have to file a personal income statement (Form 1040).

Various state and local income tax and sales tax filings need to be made periodically. However, requirements vary so much from state to state that it precludes any useful comment here. For both federal and state tax requirements, visit your federal and state tax offices and ask for the many detailed information packages available on specific tax recording, reporting, and payment requirements applicable to your form of business.

The typical income tax return (personal or corporate) is essentially an income statement. All income is recorded, all expenses and deductions are subtracted from income, and the annual income tax is calculated on this net taxable amount.

Income is easy to track and record. Expenses are not particularly mysterious either. There are, however, certain peculiarities regarding the federal tax treatment and documentation of particular expenses that are worth being aware of in order to apply the rules to your greatest financial advantage.

This is an area that is vital to either really know what you are doing, or hire a professional to handle it for you.

Pet Photography Basics

Household pets are usually not wild animals. Pet photography is a booming business. People love their pets, and many times, they are considered part of the family. They are often included in the family portrait and will even have their photo taken solo, in studio and on location shoots.

How to Start a Pet Photography Business

Photographing pets uses some of the same techniques as when shooting portraits, with a touch of the wild thrown in. Remember that they are still animals, and if they feel threatened, they will react to defend themselves. The following tips can make it easier to get good pet photographs.

1. *Consider the Pet's Personality*

Every pet has his or her own unique personality. A pet's personality is reflected in his actions and expressions. If the pet being photographed is yours, you already know the behaviors to watch for, but if you are photographing someone else's pet, ask them about their pet's personality. Most pet owners love to talk about what makes their pet special.

2. *Use a Long Lens*

Pets, just like their wild counterparts, do not like to have their space intruded upon by strangers or a camera in their face. They can react in negative ways or just turn and run away. They best approach when shooting animals, pets or wild, is to use a longer lens. I really like the 70-200mm f/2.8 lens for getting close without physically being too close.

3. *Try a Wide Angle Lens*

Try shooting close with a wide-angle lens, after you have earned the pet's trust. The distortion that can be present when shooting people very wide can be used when shooting pets. For some really unique images, try to photograph using a fisheye lens. The effect can be charming

when used on a puppy, although not so charming when used on people.

3. *Location, Location, Location*

Most times, shooting a pet at its home is your best bet. Pets are more likely to act in a natural way if in familiar surroundings. You are much more likely to get a good photo if the pet is relaxed and comfortable.

4. *Change your Point of View*

Try to shoot from the pet's eye level and see the world the way it does. If every shot you take is from above, the images will all look stale and boring. Alternatively you can also try shooting much higher above, like from a ladder, or if possible, lower than the pet. Perhaps like a cat that is perked on a higher piece of furniture.

Experiment with creative ideas to vary the height for different effects. You also may need to lie on the ground to take eye-level pictures.

5. *Capture the Action*

You need to use a shutter speed that will freeze the action of the pet. You need a minimum of 1/250second, and if you have a very active animal, you many need a minimum of 1/640. If you are having problems getting a shutter speed that fast and still getting good exposure, raise the ISO, or try getting additional light to the area.

Shoot One Shot with the Owners

Pets are considered part of the family. Make sure you get a shot of the owners. You might prepare the owner for

this ahead of time so they are dressed in the way they would like.

When it comes to shooting pets, the action can be fast, and you will have little time to check and adjust the exposure. Added into the mix is the fact that some animals are close to pure black or pure white, and some are a mix of both. This makes getting the right exposure the first time difficult. Make sure to do all your camera settings correct to the environment before putting the pet into the scene to photograph.

Ask the owner to provide the pet's favorite treats or snacks to also help get its attention during the shoot. Prepare to shoot a lot of pictures in order to get the few that really have the 'wow' factor.

Try taking pictures of the animal doing different things, playing, sitting, standing, walking, running, lying down, sleeping and any other suggestions the pet owner may have.

Some Helpful Tips

One improvement might be to place a light colored blanket on a couch or chair for which a black pet shows a preference. Black cats and dogs are especially challenging since they need a light background and some light on the face; conversely, white or light pets need a dark background.

Cat Watching

Most cats have for frequent periods of quiet alertness during which they may be contemplating a drapery cord,

following a fluttering leaf, or bird-watching. Window sills, indoors and out, are favorite perches and provide interesting silhouette possibilities, even without the cat's face. When snapping toward natural window light, set your exposure for back lighting and if, feasible, have a reflector or lamp on hand for fill-in light.

Props and Close-up

Food is an almost surefire coaxer, though you may not want a dog biscuit or a saucer of milk in all your snapshots. A ball, a length of string, a fake bone, a catnip mouse, or another plaything can be useful. Try pre-focusing on a spot to which you would like to entice the animal, then use a bit of masking tape or an extra pair of hands to anchor a suitable prop briefly on that spot.

With some assistance, you can also attempt a neat little method for photographing a small kitten or puppy close up, either at the minimum focusing distance of your camera or with a close-up lens. *On your mark*: While the helper holds the pet, place a piece of paper or other marker exactly where you want the subject to land. *Get set*: After determining the distance and correct exposure, hold yourself ready to click. *Go*: At a signal from you, the helper should pick up the marker, place the pet in position, and move out of the picture – all in one smooth motion.

Shutter Priority allows you to experiment with your shutter speeds while letting the rest of the settings continue to be automatically set. Sometimes this is the best of both worlds.

Animals, just like people, have a full range of emotions. It's always a little more compelling when you can capture a moment, not just a picture. Perhaps the pet's owner could play with the pet and you catch some beautiful candid moments between them.

This is a time when it is nice to have a full range of lenses. Up close, you will get a different reaction from animals than when you're off in the distance. Some photographers like to start off in the distance if the animals aren't paying attention to them, then get close, then back off again. Sometimes they just get lucky and get a different type of effect at each of these distances.

Sometimes it's okay to catch the bars of a cage in the picture, like in the case of this stunning Egyptian Maus cat at a cat show. It tells a story. A good photo does just that.

This taken at F-stop 5.3, 1400 ISO, 1/30th sec.

Sometimes it's a good idea to keep the background in the picture to complement the animals. With a golden retriever, the waterfall and pond helps tell a story of dedication as the dog is faithfully wading through the water for his owner. The turtles' cohabitation on the branch just looks much nicer with the rich blue tones of

the water. The red of the salamander gets a little extra pop from the contrasting color of the leaves and needles.

Pet Grooming

The pet or pets to be photographed should ideally be groomed or at least well presented in a manner that will be pleasing to their owner. This does not necessarily mean a shampoo and wet trim for every dog or bring a cat to show standard, but it does mean paying close attention to certain areas that can hamper a good portrait to at least save your editing time in post processing.

The key areas are the face, the eyes, and the vicinity around the eyes of a particular pet, so you must ensure that they are clean and free from debris. Can the eyes actually be seen? Eyes add expression and character to

any pet portrait, especially head and shoulder portraits, and should be visible. Another area could be clumps of matted coat that look irregular in appearance when compared to the rest of the coat. It is worth asking the handler to examine the pet prior to your arrival to make sure that they are happy with its appearance.

Dog groomers are certainly easier to find than cat groomers, and it can be quite a challenge on the part of the cat groomer to conduct their work when a cat is clearly not happy about having their appearance improved. Some cats may love the brushing stage, while others are merely tolerant, putting up with the routine and having become accustomed to the practice since a young age. Other cats may have to be sedated for the grooming to take place. The key decision on the part of the photographer in collusion with the owner is to assess how quickly the photography should take place after the

grooming has happened. For instance, the last thing the cat would need after being quite stressed out by the grooming experience is a photographer pursuing it. Dogs tend to be more resilient to grooming and changes of environment and should be ready for the photographer much quicker than their feline friends. It's always worth checking with the owner for recommendations of the distance of time between the grooming and the photography sessions.

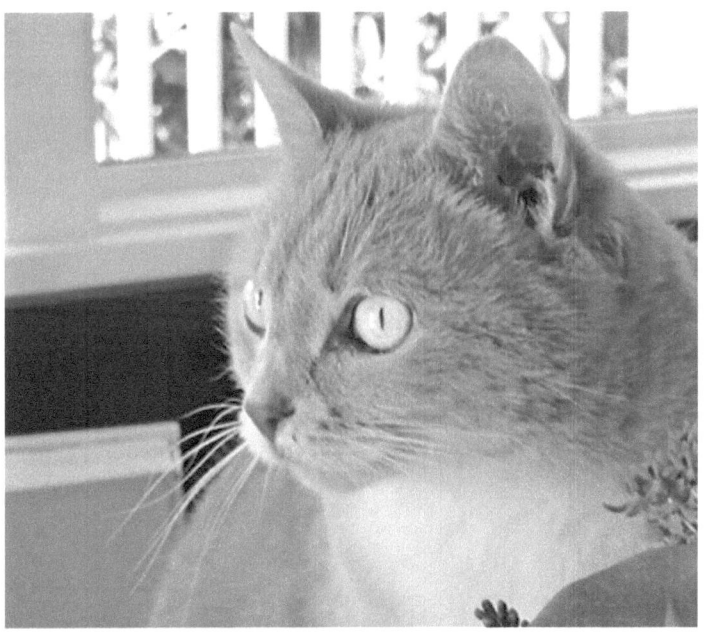

This taken at F-stop 6.3, 160 ISO, 1/20th sec.

Safety and Welfare

The health, safety, and welfare of both pets and the photographer also need to be considered as an integral part of any photographic shoot. This is particularly important in the planning stages when opting to photograph in the vast possibilities of the great outdoors. It would be a great shame if any superb images in the camera were spoiled due to an avoidable accident of one kind or another.

YOU SHOULD UNDERSTAND ALL THE HAZARDS TO YOURSELF, THE PET, AND HANDLER

For the photographer and pet handler, it is important to ensure that they have the appropriate footwear and clothing for the environment selected. That might include hardwearing boots, a change of clothing, and waterproof

items as necessary. The photographer may also want to consider investing in a pair of chest waders if entering a water environment. You will also need to be aware of the hazards that any environment is likely to present to the photographer, the pet, and the handler. Likely candidates are water, nearby roads, fields of grazing animals, broken glass, dog excrement (from irresponsible dog owners that haven't picked up), and the possible need for land permissions. If photographing on a beach or dusty environment, due regard must also be made for the tools of the trade; in other words, make sure your camera is protected from the elements.

The information obtained from the pet handler earlier should also be used to ascertain the risks of any selected environment for the pet concerned. For example, a pet's obedience level and behavior patterns will best dictate where the shoot will take place. It's important to

consider its behavior around children, other dogs or other animals, or when it is taken off the lead. This may apply to some breeds of dogs more than others, particularly those that are scent oriented or herding canines. The integrity of any leads and collars should also be checked, especially if crossing a potentially hazardous area en route to the chosen location.

The measures and planning undertaken should be proportionate to the risks. It is impossible to envisage all risks, but with proper planning and consideration, they can be minimized and the photography can be an enjoyable experience for the pet, its handler, and, of course, the photographer.

Some things to consider when photographing outdoors:

1. Pet behavior characteristics
2. Pet fitness/health
3. Suitable footwear for the terrain
4. Suitable clothing/waterproofs
5. Towel
6. Change of clothing
7. A first aid kit
8. Anti-bacterial wipes
9. Scoop bags
10. Leash/collar/harness
11. Cell phone
12. Weather conditions

It is impossible to decipher all of the pieces of the jigsaw puzzle before arriving on location, but it is beneficial to be as prepared as possible in terms of any photographic equipment needed. It's always best to ensure that you

have a reasonable amount of knowledge about the pet you are about to photograph.

Having prepared and collected your equipment, charged your camera batteries, and conducted your preparation work, it is time to meet the awaiting animal. Despite all your preparations – and regardless of whether you have several years of experience or if it is your first shoot – you will frequently be surprised or even amazed at the antics and unpredictability of characters within the pet world.

On Arrival

Upon arrival at the pet's location, it is sensible to keep your camera equipment locked and out of sight in the car. It's important to meet the pet first without the camera bag. Once on the premises, if the animal hasn't already greeted the photographer, the handler will have to be asked to tell more about the pet's traits. For example, it may be that the animal doesn't like certain sounds, being petted, or has other dislikes. You'll probably find that in an environment they're comfortable with, the owner may remember a lot of details about the pet.

With dogs and cats, a photographer's ideal strategy is often to move slowly, speak fairly quietly, and perhaps pet the animal when they think it is appropriate. It is not advisable to make direct eye contact with the animal at

first, but to wait until you think it has accepted you as a friend of the family. Certainly, never stare into the eyes of the pet. It can be a good idea to greet a pet low down to the ground, especially with rescue animals. This lessens the threat of a dominant figure and is a particular technique some photographers have used with animals that have been perhaps maltreated in the past and are naturally wary of strangers. By assuming a more submissive position to the animal, you may increase your chances of becoming best friends as the session continues. Another key part of this stage is to closely observe the relationship and interaction that the pet has with its handler. For example, how close does the pet stay to its handler during their movements around the house? How responsive is the pet to its handler's commands? Does the pet suffer from selective deafness, with its hearing improving dramatically when food treats

are around? How playful is the pet? How obedient is the pet?

Your knowledge of the different breeds of dogs or cats will give you a head start in the decision making process, but never assume anything. The objective of the introduction is to decipher what kind of shots may or may not be possible with the pet concerned (and to do this as quickly as possible). Also, if the handler has requested a group portrait of his or her three dogs, you should find out as much as you can about their dog-to-dog interactions. It's likely the owner will know which of the dogs is the pack leader, which is the most difficult dog to photograph, and the reasons behind this.

Even if you are photographing guinea pigs, the same kind of observations may be needed. Is one guinea pig tamer than another? Do the guinea pigs stay where they

are placed or move after a few seconds? Realistically, the more pets that are put into the intended photograph, the greater the odds of problems occurring, so keep some spare memory cards, and of course you'll need to have confidence that some special moments will be created.

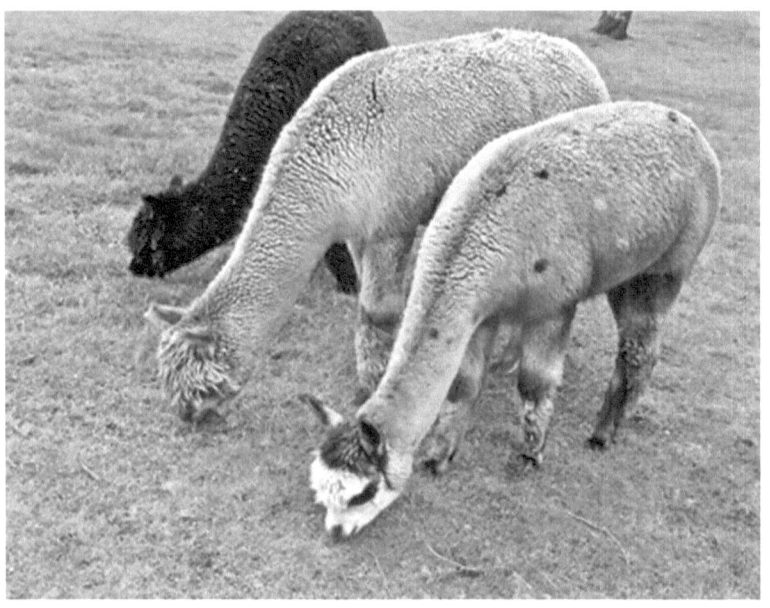

This taken at F-stop 8, 160 ISO, 1/60th sec.

Choice of Environment

Following the formal introductions, and presuming that you have been accepted by the pet (or at least tolerated), it is necessary to build the game plan that will be enacted once the camera is retrieved. The level of domestication is important: house cats or caged animals will likely need to be shot within the home. Horses may have their own field or stables, or can be transported to more open terrains perhaps with the intention to get a rider/horse image.

Dogs typically have far greater flexibility than any other pet in that they are able to be transported without a great deal of trouble and can be photographed in perhaps the greatest range of environments. It's imperative that the handler is consulted on such matters and is agreeable to the chosen destination. Nothing

should be taken for granted – the pet may have a heart condition, be intolerant of other pets or people, or have some other affliction that may eliminate location choices from the list. This is a problem you should have headed off at the planning stage, however.

Cats are more than likely to be photographed in and around their own home environment, as are small animals such as rodents. Assuming a wide choice, here is a short list of just some of the outdoor environments you may want to consider for a photography session and some of the issues they might throw up.

Woodland

Lighting may be limited depending on the density of the tree covering. Lighter colored dogs may be favorably photographed in denser woodland, but restricted light

will probably limit you to portrait images of more obedient pets. Action shots are problematic since higher shutter speeds and more light are needed.

Open Countryside

Lighting levels may be in abundance, offering greater photographic possibilities, from still portraits to high speed action. Be aware of land permissions, country roads, and surrounding livestock, not to mention exposing for the sky rather than the subject by mistake.

Sandy Beach

A potentially fantastic environment for dog and horse photography thanks to the presence of water, uncluttered backgrounds, and the variety of sand textures (from dry and light to rippled with reflective

pools). Remote beaches are preferable since they will have fewer distracting people and animals around.

Urban Environment

Dogs may need to be on a leash, but great possibilities in terms of varied backgrounds of different textures and patterns from brickwork and other manmade structures. You can also find a great variety of color tones in the built environment, especially in a commercial district. Any dog will need to be accustomed to potentially crowded places and have conducted its "business" before entering such an area.

Parks

A popular environment for many dog handlers, but there may be significant distractions from other dogs being walked off the leash and the activity of people. Quieter,

less formal areas of the park may have the most potential to provide interesting texture and backgrounds to an image, especially when the background is deliberately thrown out of focus (booked).

House

A multitude of different options, depending on the lighting arrangements, furnishings, and upholstery. Consider whether space or lighting is limited for the particular photographs that you hope to achieve. Light, well-kept homes can be gold mines of opportunity, but you are just as likely to find challenges. Good equipment that excels in lower light levels is essential.

Yard

Is the yard colorful and well maintained with neatly cut lawns? Or does it possess a wild, unkempt appearance

with longer grass and old weathered stonework? Actually, it matters relatively little, so long as the pet is familiar with and relaxed in its own territory. In many cases, the less fastidiously maintained areas are the ones in which the pet feels most at home.

Once the environment has been established, the next step should be to ascertain the possible or preferred locations within it. This means examining the light, backgrounds, patterns, working space, distractive elements, and the pet subject.

Selecting a spot doesn't mean the pet will agree, of course. It might be that a warm radiator inside the house is much more to the animal's liking, for example. The pet handler may well turn out to be one of the most useful assistants you can have.

Now let us consider the indoor environment, which is so often far trickier than the great outdoors as far as light levels are concerned.

Indoor Lighting

Explore the available rooms, examining the intensity of light both from natural and artificial light sources. Note its brightness, quality, and direction. Experiment with all the artificial light sources available to you, and take some test shots to see how the camera's White Balance feature handles them. Similarly, check to see if the natural light within any rooms can be enhanced by adjusting curtains or opening doors. It may seem obvious, but in the heat of a pet shoot, it's surprising what you can forget, especially if you are busy concentrating on the pet.

Kyle Richards

Furnishings & Objects

As you explore rooms, visualize the chosen pet in each available room or area. Will the colorings and markings of the pet allow the pet to be prominent in the scene, or will it be camouflaged by similar patterns or tones? How much does the view change as you move around the room, and can you eliminate distracting elements or colors by changing your angle? Is there any scope for moving or removing furniture or using the furniture or objects presented to hide the distracting elements? If you're in someone else's home, you'll obviously need to ask permission before it is turned on its head. Be careful, too, of antiques, ornaments, or anything delicate. Finally, do you have sufficient space to accommodate the pet, yourself, and possibly the handler from your chosen angle?

Dangers

If the pet is accustomed to a particular room, it may either not feel relaxed or be curious to explore its new surroundings. Ensure that if a room is to be used that all potential hazard are removed or minimized. For example, are there any holes in the wooden floors where the hamster can disappear? Is there rat poison in the corners of a window-lit basement? The owner of such a property will readily give you the necessary information.

Pet Portrait Tips

Many people consider portraits of pets as being relatively easy to achieve, but in many cases, they are not. If your portrait shots are to be admired, they need to be perfectly executed and also capture the character and dynamism of the subject. Portraits tend to work best when composed vertically, but your subject will dictate whether a horizontal comparison is preferable. Telephoto lens provide the necessary magnification to allow you to work well away from your subject, helping it to remain relaxed and express natural behavior. The subject's eyes will normally form the focal point of the image, so make sure they are tack sharp. Shoot as close to the subject's eye level as you can, and try to capture eye contact with a catch light if possible.

Kyle Richards

Capture a Catchlight

Capturing the sparkle of a catchlight in the eye of an animal will instantly inject life into your image and can often be the difference between a successful and an unsuccessful photographer. It is especially important with black-headed subjects, where the outline of the eye may not be obvious and can become lost in dark plumage or fur. On a sunny day, a catchlight occurs naturally when the subject is front-lit or side-lit, but you may need to wait until the head turns in the right direction for it to be revealed. In overcast lighting conditions, there can sometimes be a subtle catchlight present, and this can be emphasized in post-production work. It is also possible to use a weak burst of fill-in flash to add a subtle catchlight on overcast days, and this can be softened in post-production to achieve a more natural result. Do not, however, try to add a

catchlight where there wouldn't naturally be one, such as with a backlit subject.

Capture a Dramatic Image

Shooting a dramatic image of a pet instantly captures the interest and imagination of the viewer. There are many elements that can combine to add impact to an image, such as subject motion, dramatic lighting, punchy contrasting colors, rare or strange behavior, or an unusual camera angle.

During the photo shoot, keep alert as you never know when one of these rare moments will occur and you need to be quick to hit that button.

Kyle Richards

ost Processing

You will also need to be sure you are adept at post processing techniques. Nearly every image can be made much better with a few simple tweaks, although you want to get the original picture as good as possible to begin with. Ideally, post processing should only need a few adjustments, not a major overhaul.

A few commonly used applications are: lightroom, photoshop, and picasa, although there are many out there to choose from. Which ever you decide to use, master the use of that program. It might mean taking a couple classes to do that.

Common adjustments that may be needed are removing red-eye, adjusting white balance, slightly adjusting lighting such as bringing more light into shadow areas or toning down brighter areas. It may need the contrast

levels adjusted slightly, or noise reduction needed in some areas.

Cropping may also be beneficial for a better composition overall. With the movement of pets during the photography session, your original composition may have been completely undone.

Check the overall image to see if something is not right and needs to be cloned out. Maybe someone walked into the scene at the last second, or a fly landed on the pet or some other unusual thing happened that wasn't seen initially, but is now there.

It's a good practice to allow clients to see the adjusted pictures and give approval of them right before having their physical pictures produced. It could save both of

you hours of additional work or money lost, due to having to re-print something they weren't happy with.

This pet photography business is a creative, inspiring and challenging undertaking. Follow your instincts, do your research and enjoy the adventure!

If you enjoyed this book or received value from it in any way, would you be kind enough to leave a review for this book on Amazon? I would be so grateful. Thank you!

www.ingramcontent.com/pod-product-compliance
Lightning Source LLC
Chambersburg PA
CBHW030934180526

45163CB00002B/566